Restraint & Revolution
The Art Of Adare

By Rose Adare & Alex Stitt

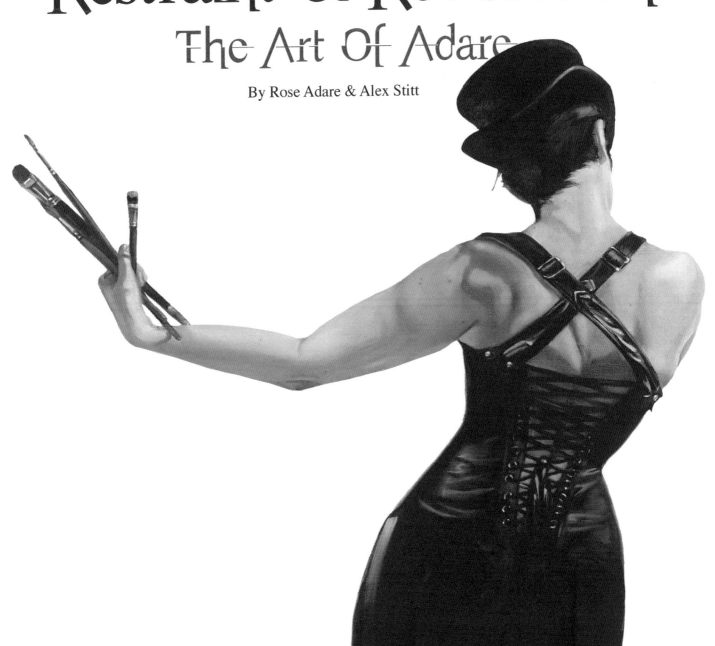

It takes a global community to create this kind of art expression.

Gratitude to all the unseen muses in my life,
to my mom and dad,
my amazing friends, teachers,
and brilliant models.
Gratitude to Alex, my Goddess, my muse,
and last but not least:
Gratitude to that train.

Front Cover: *Venus Unbound* from Restraint & Revolution ™
by Rose Adare, 2013. See Page 90.

Second edition.

Published in the United States by CreateSpace.
ISBN-13: 978-1500221492
ISBN-10: 150022149X
BISAC: Art / Individual Artists / Artists' Books

Table of Contents

Foreword
By Alex Stitt

"I need a foreword for my book."

"What about?"

"About how we got here."

"We?"

"All of us ragamuffins. How did we get here?"

It was a simple question. The vast ones usually are, yet Rose Adare had a far more specific meaning. As a painter she had just begun her new portrait series *Restraint & Revolution*, an incredible feat capturing the dynamic faces of millennial counterculture—and they were all so diverse. No two were alike, and yet they all rocketed out of the normative box with interweaving smoke trails. They were all connected somehow, and I knew the answer lay in art. So I told her:

"Typhoon butterflies."

Every Western empire has undergone a cultural chrysalis. After a booming economic growth, the imperials expand their borders to export their morality. Yet when the military spreads too thin or the empire falls on hard times, senseless wars emerge to bolster the banks; fanatics openly discriminate against whatever out-groups disturb them most; and the politicians squabble along ridiculous lines drawn in ever-shifting sand. After a while the crowd begins to whisper, and with civic unrest looming on the horizon the empire coddles its people in a patriotic cocoon. From the crumbs and clowns of ancient Rome to the sensationalist media soliciting our private living rooms—the spin remains—albeit as stale as Antoinette's cake. At this time the discerning people rebel, and as the jingoistic shell shatters, a butterfly emerges—a bohemian survivalist ready to leave the old mentalities behind.

Social uprisings are natural, yet not every revolution is a renaissance. Observably, a bohemian revolution is a new, innovative, and above all artistic subculture within an otherwise stagnant society. It's not a war between nations or a dispute between opposing sides of the government. On the contrary, it comes from the streets, not the congress, from the poets, not the orators, and it comes every time from our children.

Beatniks, hepcats, rebels, rockers, hippies, goths, punks—the very face of the bohemian ideal embodies whatever Socratic message the dominant culture has forgotten. The image of the foppish dandy sipping café crème at the Rotonde is a pigeonholed allusion to the Montmartre uprising, yet history isn't made of cinematic caricatures. Sid Vicious didn't encompass the anarchist movement, and not everyone in the 60's dressed like Jerry Garcia, but external observations of fashion are sometimes the only way for people to draw that intensive line between "us" and "them."

A bohemian movement is born within a social context specific to their ideals. They are the dissenters. They are the sons who rebel against their materialist fathers, and the daughters who discard their mother's complacency. Their exact message evolves as frequently as their art. We can allude to a progressive or anarchist nature, but these are observations of the past that hold no bearing on the future. Many would use the term *bohemian* synonymously with *counterculture* given their longstanding overlap, yet there is a key anthropological distinction. Counterculture includes any group subverting the predominant power, including religious, political, and racial minorities seeking their own voice. Observably, the

suffragists differed from the sex-positive flapper feminists like Victoria Woodhull, Margaret Sanger, and Emma Goldman. Likewise, Malcom X, Audre Lorde, and even Bob Marley represented very dynamic scenes within the equal rights movement. A very similar shift can be observed today, since the gay rights movement seeking fundamental equality does not entirely reflect the fabulous queer parade looking to explode your mind.

Amazingly, what is truly shocking—truly cutting edge—becomes even more daring with each generation as the mainstream adapts, adopts, and markets the image. Bohemians are therefore human prototypes exploring the ideas, ideals, and conceptualized truths at the very edge of society. Many of their ideas never catch on, and many more are diluted by marketers wanting to cash in on a popular, alternative trend. But through art, music, and self expression, bohemians have changed the course of history from within by changing how we see the world.

Trampled rebellions inspire further rebellions, and while countercultures strive for liberty, bohemians express the feeling of the hour—creating some of the best historical accounts without use of words. As such, it is the goal of all bohemians to become typhoon butterflies, to change the conscious world with an idea, a thought, an image, a painting, a sculpture, a play, or even the intro to a book.

"Nice."
"Thanks."
"It's a bit wordy, though."
"The ragamuffins will like it."

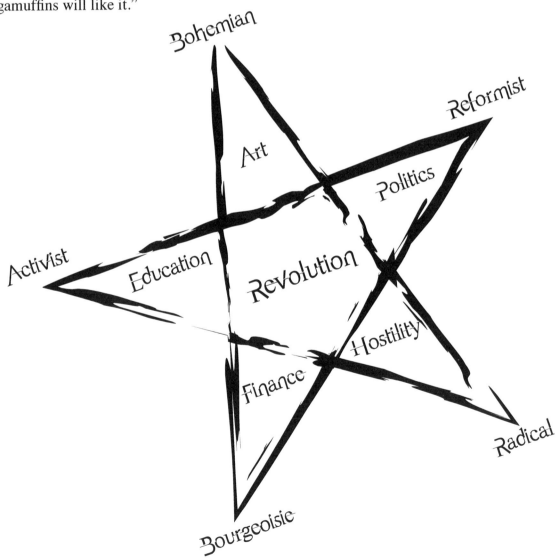

People are different. Diversity is beautiful. Respect is key.

Restraint & Revolution

Restraint & Revolution celebrates self-expression. Each amazing model in this series is tied with a unique form of corsetry as a symbol of their own personal ties. I have always adored corsets. There's something timeless about them. I've found them everywhere, from Chinese rope bindings, to Hawaiian armor, to European bustiers. When I see a corset, I see a very long history cinched together with intention. In America, what was once a chaste under-garment, imposed upon women, is now naughty lingerie. What was once a hidden secret is now worn over our clothes.

Intentions change. Society is redefined. In the same way, to be bound can mean imprisonment or connection. We can be bound by shackles, or bound on a journey. We can be bound by society, oppressed, censored, and tied down, or we can be bound to passion, conviction, and the personal truths that shape our identity. Perhaps it's our past, and the need to keep our heritage alive. Perhaps it's our future, and our new creative vision.

Restraint & Revolution is a portrait series examining a small handful of amazing and innovative people. Each person represents, in their own way, a part of the rich cultural scene carrying us into the new millenium. *Restraint & Revolution* takes a deep look at what binds us expressively, sexually, and spiritually, and it looks at how we grow.

I felt compelled to paint this series because of my style. As a classical painter from the San Francisco Academy of Art, I went on to study at the Temescal Atelier for Classical Realism. There I studied under David Hardy, who, in my opinion, is one of the greatest color theorists in America. A living Master, David Hardy's dynamic use of color combines elements from his own tutors, Antonin Sterba and William H. Mosby of the American Academy of Art in Chicago, and Joseph Van der Brouk, graduate of the Royal Academy in Brussels.

Incorporating elements of Classical Realism, I heat up the old world techniques to form Evocative Art. Each portrait takes over 100 hours to complete, using only archival quality Belgian Linen, or 12 oz American Cotton (for paintings over 10 ft). The under-drawings follow the vesica piscis with Palo Santo charcoal. Combining Gamblin® oils and gold leaf, I then infuse my paints or varnish with unorthodox ingredients like hemp oil, whiskey, peyote, or blood, depending on the cultural lifestyle of my subject.

As an artist I love diversity as much as I love mixing a new palette, yet portraiture is unique. Photographs capture a moment, or even an emotion, yet a painted portrait captures an essence. I know when a painting is finished because it will appear to breathe. It will take on a life of its own. There's a kind of magic there that draws people in.

Classical art is very structured, often preferring elegant women or stately men. One rarely sees a full range of diversity. The irony of painting non-classical people in a classical way is obvious, but not the point, since we're always redefining normality. *Restraint & Revolution* is all about inspiration. Each painting can stand alone as an archetype, yet the layers and labels melt away when you read their stories. I am very proud of every person in this series, because they have all lived the change they want to see.

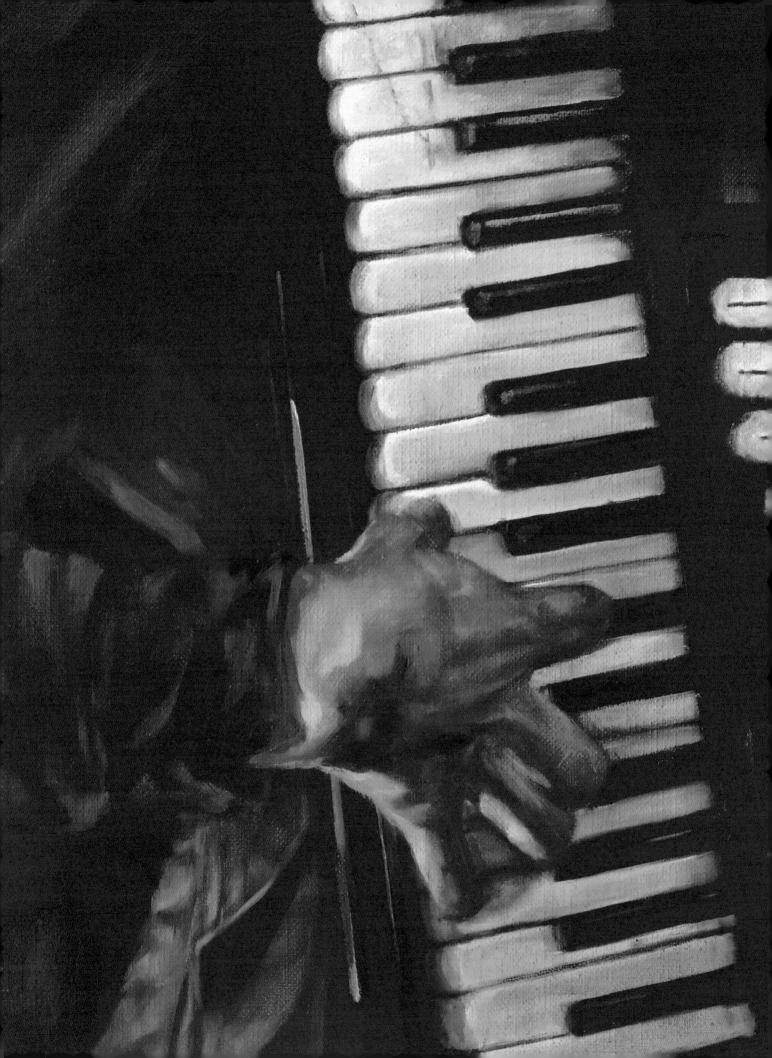

Jason Webley
Oil & Whiskey Varnish on Belgian Linen
24 x 48 in.

Jason Webley began his career busking on the wet streets of Seattle. Traditionally "dying" every Halloween to be reborn for a concert in the spring, his fans would make a spectacle, driving him away in a hearse or, on one occasion even burning his signature porkpie hat.

Surviving the Halloween of 2005, Webley is still alive and cutting albums with his own label, Eleven Records.

Driving a giant red tomato reincarnated from a Toyota Corolla, he built Camp Tomato, a playful romp of fun and music devised after someone accused him of being a cult leader.

Jamming around the country, Webley developed the Monsters of Accordion tour (featuring Corn Mo, Geoff Berner, Amy Denio, Stevhen Iancu formerly of Gogol Bordello, and Eric Stern of Vagabond Opera). Joining up with Amanda Palmer of the Dresden Dolls, Webley became one half of Evelyn Evelyn, a Siamese-twin sister act working concomitantly to play the same accordion or ukulele.

www.JasonWebley.com

I remember a wheezing accordion, and dust drifting from the billowing canopy. The first time I saw Jason Webley was at Burning Man, under a windblown tent. Outside, flamethrowers illuminated the desert sky. Neon giants moved in the dark. Yet of all the bizarre fantasies at Burning Man, a few excited friends of mine had whisked me into a wind-blown tent. An intimate crowd huddled inside as a man in a tipped hat tuned his accordion. I didn't know what everyone was waiting for, until he sang.

His voice was parched, but not because of the Nevada dust. His voice was like gravel, and his lyrics carried a kind of heartfelt, poetic thirst. He sounded like a pirate singing about the apocalypse. And he was wonderful, and funny—the kind of funny that recognizes this mortal joke. When he stamped his feet, clouds of playa-dust kicked into the air, and as his audience sang along, he shook a bottle filled with pennies.

It wasn't the last of his concerts I went to, visiting small coffee shops or booming barrooms. Jason has a kind of personable nature, friendly, witty, and very thoughtful. When I asked him to model for a painting, I was in San Francisco, having flown in from Hawaii, just as he had driven down from Seattle.

Borrowing a green corset from Autumn Adamme's Dark Garden corsetry, we set up the image, but I didn't recognize Jason. He was so shy. Having shaved his beard he looked younger, and since he didn't know what to expect, he felt kind of drawn in.

So I asked him to play.

Picking up his accordion, he tapped a few notes—then he slammed his foot down, and there was Jason Webley! A guttural roar. Every other artist in the studio turned, as Jason belted an impromptu rendition of "Dance While The Sky Crashes Down."

In the painting, I set Jason against an impressionist, rain drenched city. Maybe Seattle, where he began as a busker, maybe San Francisco, or New York, or Moscow, or your own hometown. The city's anonymity was important to me, because Jason embodies the traveling poet, singing with whoever he meets, sharing his art wherever he goes. He's notorious in the college circuit for dropping in, pulling a bunch of students or musicians together, making up a song, and posting it online.

I mixed whiskey in with the varnish and drank a good deal myself. One for the varnish, and two for me. I'm particularly proud of the scuff marks on the accordion, the evidence of a well loved instrument, yet my favorite aspect of the whole painting are his trousers. Painting thick, rough denim, dancing in motion, was very liberating, especially after all the detail work on the squeezebox. Webley's guitar work is excellent, and he's a genius lyricist, yet there's something so iconic about his accordion. It's a complex instrument, nostalgic but very new when compared to most in life's orchestra. It's technological, modern, but the sound is also raw and boisterous. I remember one show in Ashland, OR, when one of the buttons flew off, causing one of his keys to wheeze with every other note. No one could stop laughing.

Later, I asked Jason about his mysterious reference to the number 11, from his song 11 Saints, to his record company Eleven Records. While 11:11 is symbolically well known, he told me he once had a love in Hawaii. Traveling on Highway 11 to go see her, he found his obsession with the number. There are quite a few 11's hidden in the painting, as they kept popping up, in my studio, on Highway 11, on the Big Island of Hawaii.

Some say 11 is the number of serendipity.

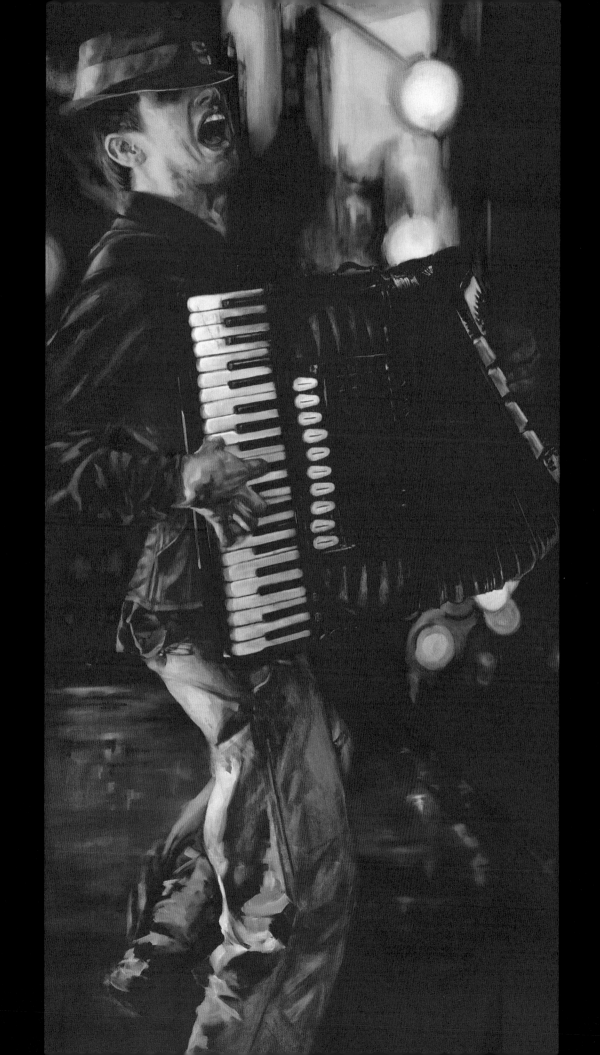

"Bring Me
My Ghosts"

Ariellah Darker-Still
Oil & Silver Leaf on Belgian Linen
24 x 48 in.

Growing up in a Moroccan family immersed Ariellah in folkloric dance and rigorous ballet training, yet when her belly dance instructor gaspingly asked where she learned her style, Ariellah could only say: "The Goth Clubs."

Finding a new family of thespians, goths, and misfits in the Bay Area's infamous Deathguild, Ariellah embraced the Goth culture, taking the evolution of old and new into her choreography. Traveling as a teacher, performer, and volunteer in the West Africa Peace Corps, she continued her journey as a lifelong student of dance.

Evolving her Dark Fusion style, she combined the classical Odissi technique from India's Shakti School of Dance with the controlled steps of Thailand and the dusty raves of Burning Man.

Featured in magazines and radio shows, Ariellah won first place in the Star Fusion category of Sirens In Sanity's belly dance contest (2004). This led to a series of DVDs, including the first film of its kind, *Gothic Belly Dance: The Dark Side of Fusion* (2006). Currently, her first instructional video, *Contemporary Belly Dance and Yoga Conditioning*, is one of the top selling and highest rated belly dance DVDs on market.

www.Ariellah.com

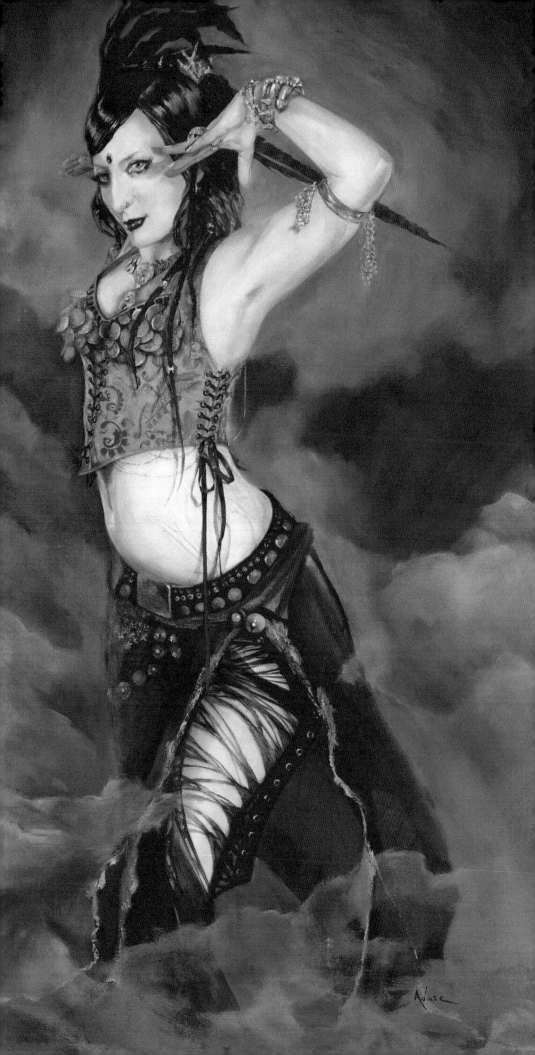

"You spend portions of your life in a place where, it appears—maybe even to you— that you're just spinning, because you're saying: I can't do that thing that will allow this other thing to happen.

Your soul is going to win until you begin to poison it. I think giving up on yourself is a kind of poison. I think believing—whether it's a good or bad thing—believing first what other people say about you, can begin to do that. There's some slow stuff out there, too. Slow little allowances, and you turn around and you kind of go: Wow I'm sinking! And you can pull yourself out, but you have to watch out for that stuff."

— Robert Moses

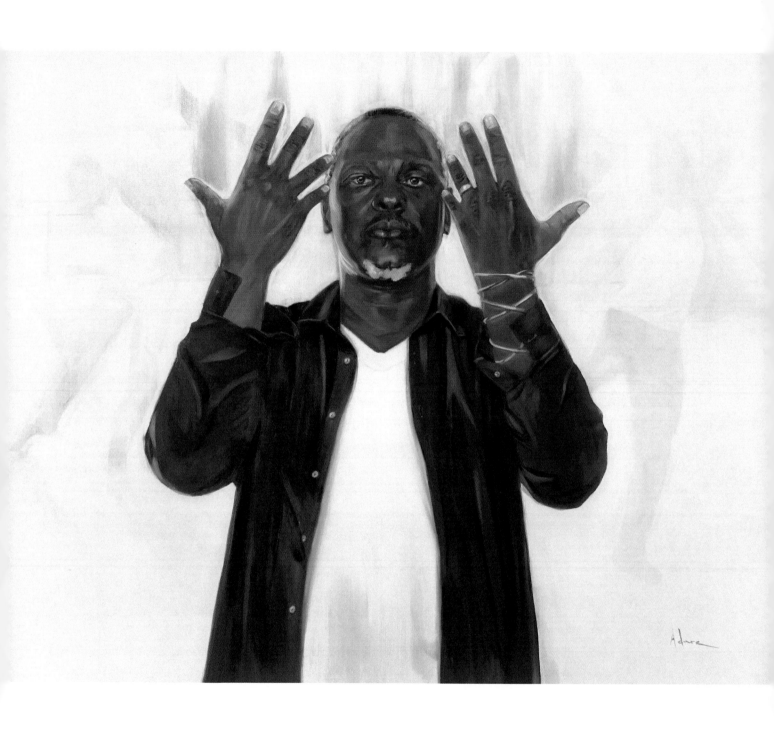

Reshaping Reality

Robert Moses
Oil & Metallic Paint on Belgian Linen
48 x 36 in.

Exploring concepts of class, culture, and racial identity through the power of neoclassical ballet, Robert Moses impacted the Bay Area dance scene with a fierce choreography emphasizing socio-political expression. Founding the dance collective Robert Moses' Kin in 1995, Robert was awarded the dual titles of Choreographer-in-Residence and Artistic Director of the Committee on Black Performing Arts at Stanford University.

"People come to class for a lot of reasons. Beginners come to class because they want to get past that place. They have that hunger that they want to move, or they've seen this thing and they want to have an experience, or they want to be able to communicate something, or there's something about it that they're seeking that can feed them. I think that's why beginners come when they start, and I think professionals come because they want to hone it. They want to get closer to putting a finer point on the paper or the page, and be more articulate, that's why they come."

Learning from, working alongside, and later teaching some of the brightest stars in contemporary dance, Robert Moses travels internationally, having choreographed shows for the San Francisco Opera, the Oakland Ballet, Eco Arts, Phladanco, the Cincinnati Ballet, the Transitions Dance Company of the Laban Center in London, the UK's African Cultural Exchange, the new Conservatory Theater, and the Olympic Arts Festival—to name a few.

From content driven commentaries to explosive free-form motion, Robert's energetic style fuses skilled control with seemingly erratic spontaneity.

"You know when you have a conversation with someone and you push a button? That's where things come from. Anything that pushes a button, somehow—which means I've got a lot of corners. Things that push buttons are the things that make me generate. Like the silence of artists. 'Censored' is the wrong word, because you find another way around it, but being subversive and being an artist is kind of a weird combination—unless you're obviously subversive. It's one thing to wear a mask that says 'I'm sad,' when I'm feeling sad in a particular way, but to wear a mask that says 'I'm sad,' when you're actually indifferent is something else. Paint the indifference. Dance the indifference, in a real way! That's one of the things that pushes my buttons—if I see something that I think is not real.

I do a lot of approaches people consider political. I'm told that I do that, but it's really that button pushing thing. If I see something that concerns me for some reason, it comes up in my work. No, I don't tap dance around it, but in finding ways to make something clear to people you have to consider how you're presenting it. I don't think that I censor myself. I hate that word, but I do find ways to make things palatable enough so that people take it, listen to it, and consider it. Then I try and give it the most impact I can, but I don't tap dance around it."

Robert Moses continues to perform, teach, and inspire via his troupe, touring nationally as one of America's most evocative dance companies. Recognized for their collective talent, Robert Moses' Kin has earned four Bay Area Isadora Duncan Awards, the San Francisco Black Box Award for Choreography, and the Bay Guardian Outsanding Local Discovery Award in Dance.

Rhinos on Fire in the Garden

Sarah Soward, Rose Adare, Sharon Eisley
Oil & Metal Paint on Belgian Linen
36 x 48 in.

"I believe in muses. I've seen them headless in Rome and as sensual as the *Three Graces* in London's V&A. I wanted to capture that essence in our time, from Punk, to Burner, to Steam-punk. As an homage to friendship, this portrait includes Sarah Soward, myself, and Sharon Eisley, lifelong friends and founders of San Francisco's *Muse Showcase*. Each is wearing a corset, hand painted by the artists in their own unique styles. I also believe in the unsung muse, the artist hardly seen, represented here by my poet sister Kay Sundstrum as a portrait on a painted corset, within a portrait."

—Adare

Graduate of the California College of the Arts, painter, programmer, instructor, and designer, Sarah Soward's real passion rides on the soft hide of a rhinoceros. Taking rhinos beyond the physical, her Rhinotopia™ series explores the spiritual symbolism of one of the world's most misunderstood animals.

"I believe in Rhinoceros, the creature deserving, crasher of Savannah and jungle. And in Diceros bicornis, the two horned rhino, our friend; who roamed Africa freely, untamed; now hunted by poachers, dehorned, and left for dead; the rhino dies, does not arise again from the dead; the rhino rots and is eaten, becoming one with the earth; from there new life springs that would feed future rhinos if there were any that lived. I believe in Rhinoceros unicornis, the rhino of the one horn, the Greater and the Lesser; the Sumatran rhinoceros, hidden in shade, twice horned; and the cycle of life recurring. Oh yes."

— Sarah Soward

At 11 years old, Sharon fell in love with Chinese brush line, becoming a painter in a family of psychologists. At 15 she fell in love with her future husband Norman, following both passions to Taiwan. While studying Mandarin, she painted Chinese Santa, and people breaking their heads open to reveal new people inside. Returning to the US to finish her BA at the California College of Art, she continues to mix art into her daily life.

"Two young boys orbit me, freckle face and frolicking in my Northern California urban homestead. I have been happily married a long time. I am an artist among many here. But when I go to my studio I don't paint grapevines or rolling golden hills, I paint animal headed people, trees twisted with origami. I paint from myth and from the bubbling up of the collective unconscious. I try to rethink our paradigms of what and who we are."

— Sharon Eisley

www.SarahSoward.com www.SharonEisley.com

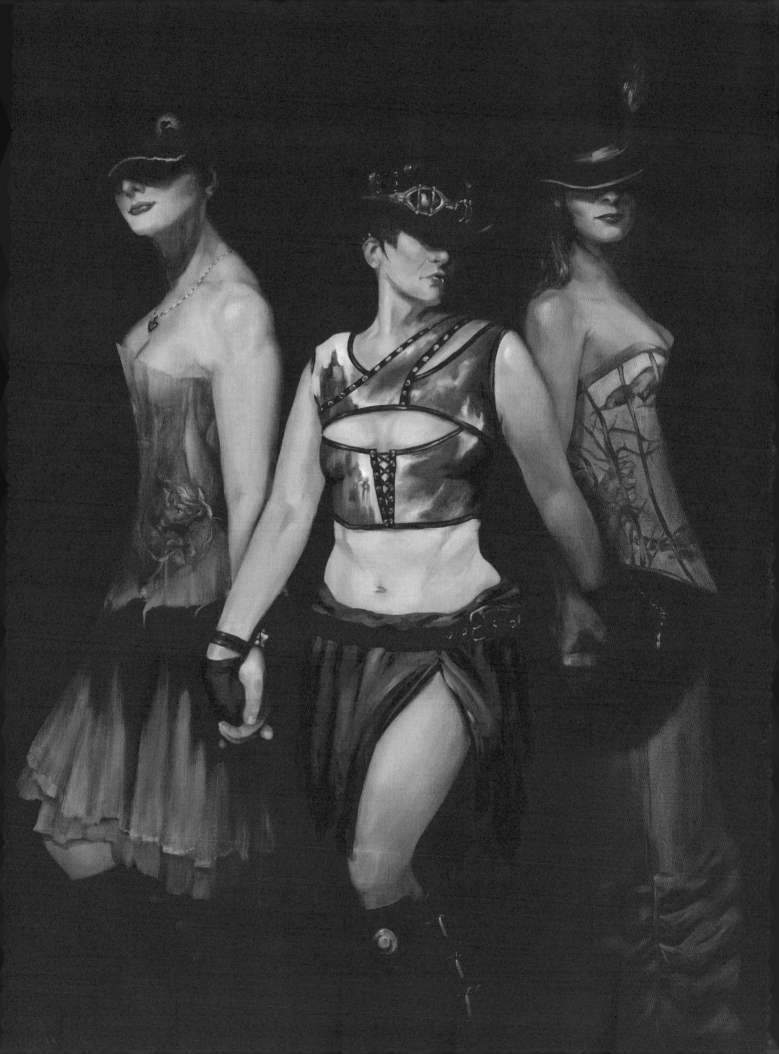

After a solid structural under drawing, I thinly layer oils to create a luminous sheen where the canvas shines through. Blending around the edges allows the viewer to focus on areas of detail, just as the eye would naturally refocus. This allows certain areas of a portrait to take on an impressionistic quality, while reserving sharp concentration on the painting's primary lines of action.

Teaming up with my good friends Sarah Soward and Sharon Eisley, we founded The Muse Showcase in San Francisco. An evening of art and music,

we featured our work alongside the photography of Alison Seal and the corseted musical extravaganza, Rosin Coven.

Solo, I was starting to pick up shows at the Sutter Gallery and Epic Arts, while entering numerous group shows, the most notable being a Toulouse Lautrec Retrospective at the Legion of Honor, one of SF's most prestigious venues, where my work got to hang alongside one of my idols.

I learned quickly that the art world was sharply divided between art-as-business and art-as-expression. Gallery wall space is expensive, so they need to cater to their demographic. Museum curators treat artists as investments, pushing them to grow beyond their means to attain their potential, which makes their grace even harder to attain. Likewise, private art collectors often want to live vicariously through la vie bohème.

I remember being flown to New York by a man who swore up and down it wasn't sexual. He lied, and I ended up leaving—his drawing of Nike half finished. In any circumstance, an artist needs to know their self-worth, and that's the true revolution.

The restraint of the art world is the perpetuating idea of the starving artist. By the time you pay for canvases and materials, and after the gallery takes a 50+% cut, artists aren't paid for their time. In this old paradigm, artists aren't expected to make a living. Yet art is a business. You clock in and you clock out: 40 hours is full time, 15 hours is part time, and a weekend artist paints a little throughout the month. Each portrait takes between 60 to 200 hours, not including marketing or business management. More importantly, art is expression, and the fear of expression is another Restraint. Artists are often apologetic. It doesn't matter what their talent level is, many artists don't believe in themselves, or else feel guilty for trying to make a living out of their creativity. They see the self inflated artists and they don't want to seem so arrogant, so they downplay their work. Yet there's nothing arrogant about standing up and saying: "This is who I am and this is what I create."

On the other hand, complacency is a curse and when people think their talent is good enough, they stop striving.

In 2004 my car was hit by a municipal train. I was backing out of a parking spot. A 60 ton trolley-train was coming down the hill. The driver had just come off an all night shift driving a transit-bus. Thinking she was

still driving a transit-bus, she was planning to swerve around me, but since she was driving a train instead, my car was impacted. But I didn't break a thing. Instead, being hyperflexible, all my bones popped out of place. In shock, I felt nothing. I even climbed out of the window to ask the train driver if she was okay. She asked if I needed an ambulance. I said no and walked to Sarah's house.

The next day I went to work, but I kept dropping things, so my boss sent me home. The second day I went

I was naturally flexible, they didn't stay-put—which, combined with the cold of San Francisco caused my whole body to tighten up in all the wrong ways. Even my fingers curled arthritically until the only way I could hold a pencil was to tape it to my fingers.

Homeless for the second time in my life, Sarah took me in—valiantly fighting the post office after a mailman called me stupid for not being able to think through a pain fog.

After that, I was taken in by my friend Koyote. I remember waking up agony, unable to breathe, and he would work on my body, puttng me back together. He is one of the true angels of

to work, and I kept dropping things, so my boss sent me home. Hired assistants aren't allowed to drop things. The third day I couldn't move. I wound up in ten body braces with severe muscular atrophy.

Unable to pay my medical bills or my school loans, I went bankrupt, learning very quickly that a lawsuit against the city of San Francisco is nearly impossible to win. Two lawyers (and two assistant lawyers) to my one, they used my sexuality as evidence of my health, insinuating the old cliché that disabled people aren't sexual, and if I was healthy enough to have sex, then I was healthy enough to work.

My bones had supplicated out of place, popping in and out with the slightest pressure. Walking up a flight of steps dislocated my hip. Picking up a five pound bag of sugar popped out my shoulder. I even amazed a chiropractor by popping three ribs and my sternum so far out he could move his hand along its side. When he asked what I'd done I told him: "I sneezed."

Everything had detached, and since

my life so I painted him like the devil, like the wise trickster that he was.

While preparing for this portrait series, I went to visit Koyote in October of 2013. He had just had a kiwi sized tumor removed from the palate of his mouth.

Having battled cancer since the age of 10, Koyote transformed himself into not only one of the healthiest people I have ever met, but also one of the most sincere. While both a physical trainer and masseuse, I had originally met Koyote as an art model. He could flex every muscle, tantalize every thought, and he had a way of speaking, because of his throat cancer, that made every conversation take on a hushed, excited whisper. Truly one of those people who spoke more with his eyes.

Koyote died about six months after his interview, in a bike collision with another vehicle. Short of kicking the bucket while having sex, the man died doing what he loved, with the same intensity and passion that he had for life itself.

Koyote
Oil, Silver Leaf & Blood on Belgian Linen
24 x 48 in.

Diagnosed with throat cancer at 10 years old, Koyote's doctors gave him three lifetime doses of radiation in six weeks with a cocktail of four separate chemo-drugs, entirely lethal on their own, all before anti-nausea meds came onto the scene.

"Having cancer is probably the best thing that ever happened to me. After that point, everything that happens to me is good, 'cause I'm supposed to be dead."

Athletically driven, Koyote became a kinesthesiologist, a certified masseur, and a strength conditioning specialist in the National Strength Conditioning Association. Working as a physical trainer, he cultivated a small business, a beautiful marriage, and a conventional life until 2002 brought yet another change.

Morphing his body, his politics, convictions, religion, and sex drive, Koyote emerged from his former skin as both a fire dancer and an art model, bearing one of the most recognizable torsos in the Bay Area Model's Guild. Yet art and fire were secondary to Koyote's sexual conviction; maintaining sex as the richest form of expression. Helping others to enjoy, explore, and enlighten their sexual selves through achievement of movement, self acceptance, or by simply providing a safe haven, Koyote indwelled his love of life and body.

"Oddly, I am truly a shape shifter...the other half of you-and-me. I am who you manifest, having very little residual personality when alone. I am your secret, guilty, fetish voice, always enabling you to do that which your visceral urges compel...the classic devil."

— Koyote

"If, for example, I was going to throw you over a cliff and you thought you were going to die, but I had a rope on your ankle, and you didn't know it, and at the last moment I caught you, and pulled you up, and let you go, you're free! Now everything that happens to you is good! If you're at a stop light for two minutes, it's fine. If you're having someone drill on your tooth, it's fine. Because knowing that you have been there before—at the end of that rope? All experience becomes good. And my thought is that the very, very worst thing you will ever have—maybe it's twenty-four hours of painful torture? And then you die. You were going to die, anyway. You were always going to die, so anything shy of that is experience. And when you get there, when you do embrace Kali, it's only death. It's only death, and that is the fear. Beyond that...? Pain and death, that's all. So live life if you choose, or die young if you choose, but the pain is not that bad, and the good is that good.

You probably know this, but the word Satan comes from an Arabic word of old, meaning the Other Voice. My experience is that I am always the other voice. So if all of your family loves you, but they want you to be a certain way? And live a certain life? And you meet me? I love that you do all that stuff! That's good. But in the same breath, that's not who you really are.

I want to know what you want, and the reason I exist is to enable, and tantalize your becoming of what you want. I'm going to aid you. That's what I do. So if you want to start a business, fuck your job, and get a new car, I say: 'How do we do that?' If you want to leave your husband, fuck that guy and three women, and join a cult, I say: 'So what happens if you do that? Let's research it.' I push you a little more, a little more, a little more to help you understand. In my experience, I don't cause that change, I only hasten it. So whatever you want to do, I want you to do.

If I could say one thing to be left with everybody, I would say this: What happens if you do it? There's something you want to do.

Maybe you want to answer back when someone is in your face. Maybe you want to try something. Maybe you want to leave a relationship. What happens if you do? You're going to die anyway, and you're only here for a time. Do it. And see what happens, because you know what happens if you don't do it.

Do it."

— Koyote

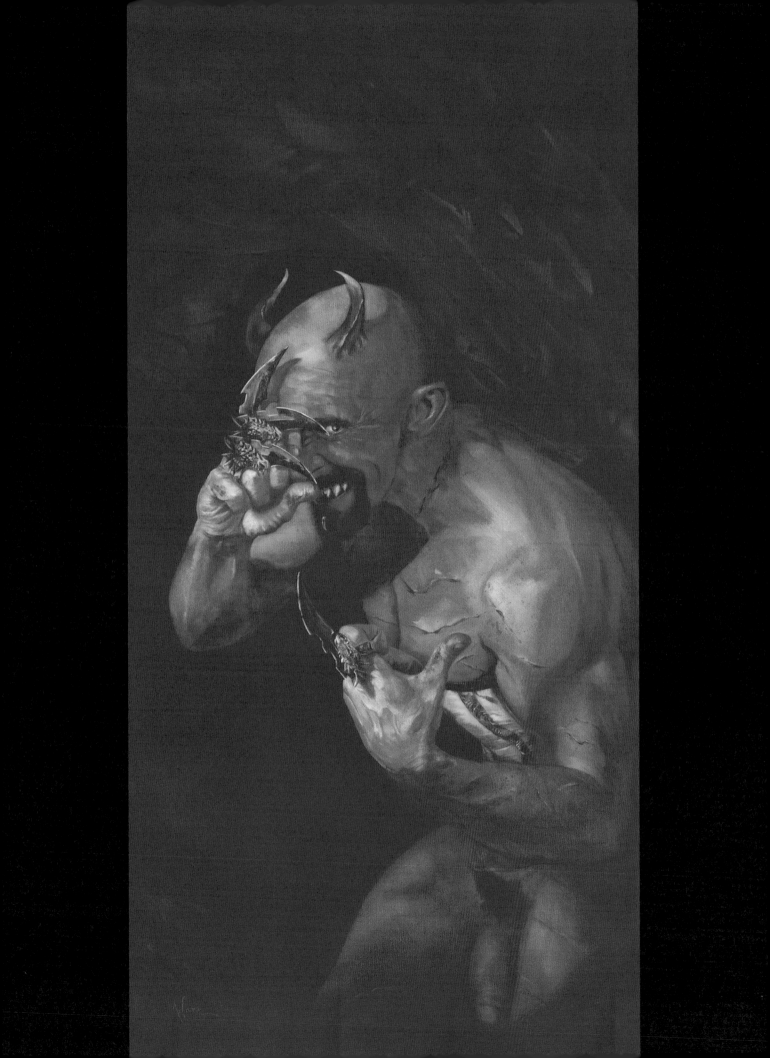

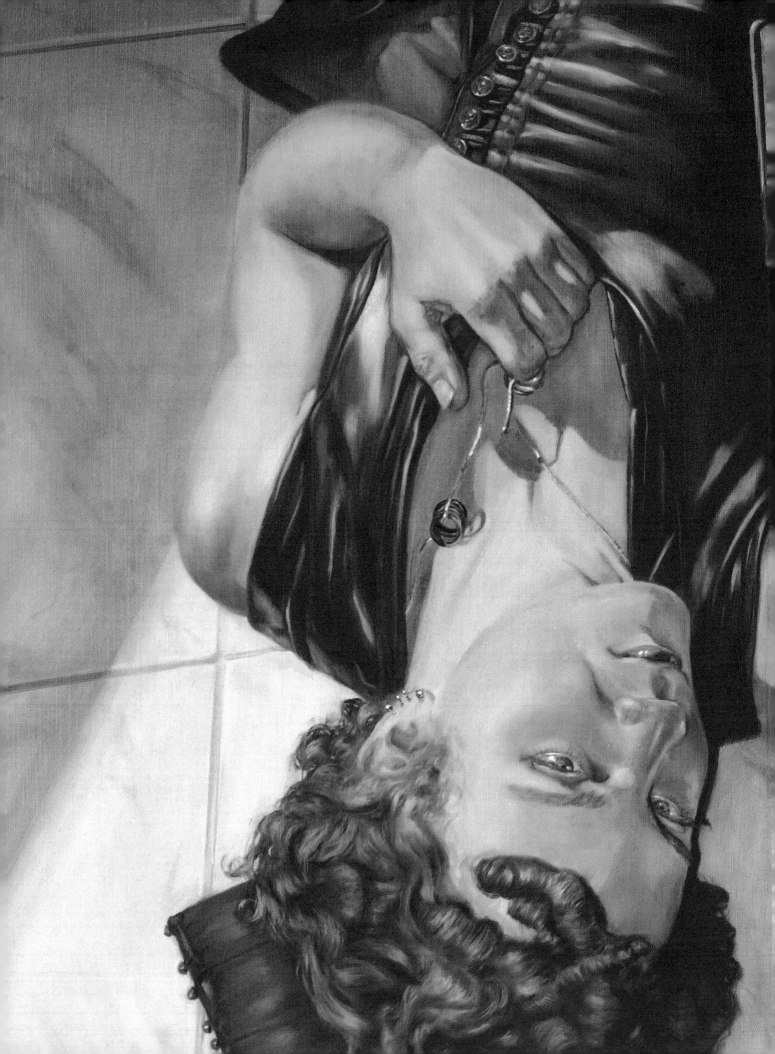

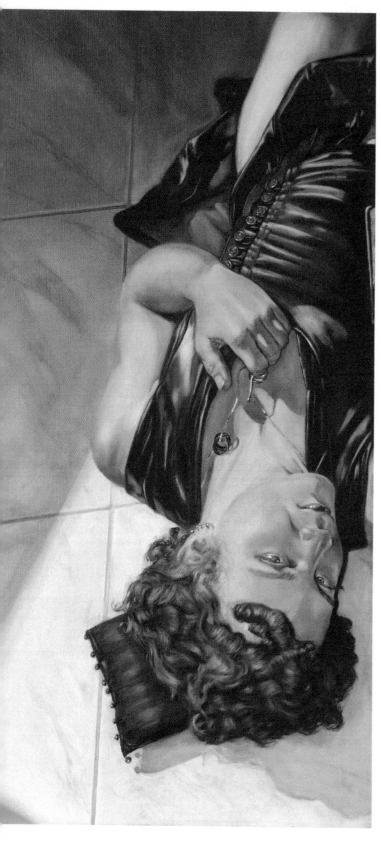

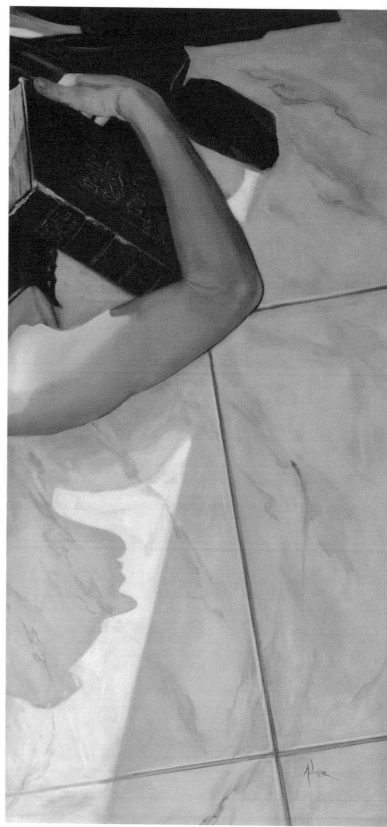

Cupidon

Alex Stitt
Oil & Gold Leaf on Belgian Linen
24 x 48 + 24 x 48 in.

Raised in Cornwall, England, Alex grew up reading tarot cards, hopping leapfrog over the old witch stones, and playing in a castle at the end of their road. An eight year-old raver, Alex followed the age of carnival from Glastonbury to Burning Man, becoming a fire dancing novelist. Penning their first book at eleven, Alex continues to produce bohemian, gender-bending fiction, including: *Tiresias Bitten* and *Voodoo Jazz*.

"Stay-at-home writers are doomed to cliché, bibliographical fantasies imagined by long dead authors. To write, you have to have a life worth writing about. You have to live with as much intention as you give your story. One of the stranger jobs I've had, for example, was as a security guard on an active volcano. There I saw four houses and two miles of the road melt, at the edge of the world where the land's made new again. Whenever possible, I'd wait for the lava to get within 10 feet of the barricade before I moved the tourists back. The ambient heat's like a furnace at that distance. Life's not real until you feel it."

Dodging gunshots, knives, cars, and rocks, Alex understands prejudice and the need for queer visibility. A self proclaimed "psylosopher" with a Masters Degree in Counseling, Alex's published journal articles expound on queer identity acquisition, exploring one of the last dark continents of sexual psychology. An Ally Trainer and LGBT activist, Alex aided their trans friends through sexual reassignment surgery amidst the Thai Revolution; led LGBT support groups in Hawaii; and continues to lecture on gender diversity.

"My favorite topics are love and death, because only one is optional. In my short life I have fallen in love with men, women, transgender men, and transgender women, as both a man and a woman myself. Fluidity is rarely recognized, let alone understood, even within the queer community. As all shape-shifters know, people presume you are as they perceive you to be, sans past, future, or identity. This is saddening, for as all shape-shifters know, face value is a convertable currency when you have more than one face.

Admittedly, the nebulous life experience is disconcerting, so people favor concrete ignorance over naive innocence for fear of vulnerability. People would rather not ponder the unknown, for structure—while limiting—is at the very least stable. Yet love is a vulnerable courage. Love cuts through all our imagined fronts to the core of who we really are. Love makes us feel small and immense. Love shows us the infinite in the infinitesimal.

And sex! Sex is the simplest and most beautiful act humanity ever overcomplicated. I could tell you I'm a polyamorous pangender pansexual, and you might smile at so much alliteration. Or you could tell me your favorite dream, and we might just meet as real people, fluid in the present—provided, that is, we're brave enough to be gentle. Yes. My favorite topics are love and death, because they're both so mystifying. They're both so human. As we do not remember our birth, I'm inclined to believe we will not remember our death, and so we exist, passing like the sun through mist, with nothing but the day to call our lives. This is why peak experiences are so important and so formative. Most people only have a handful of poignant memories, yet I, at a very early age, hunted the magic of the moment, knowing all too well that nothing else amounts. Subtract sleeping, waiting, driving, preparing, unwinding, maintaining, and leave only the most everlasting memories and you'll find we're all experiential children.

We are all mandalas in Buddhist sand."

www.Alex-Stitt.com

Dreams of a Dusty Penguin

Karen Cusolito
Oil & Playa Dust on American Cotton

120 x 30 in.

Karen Cusolito is an epic metal work sculptor, her towering thirty to forty foot giants looming on the dusty plains of Burning Man. A surreal fantasia of 50,000 people gathering in the Nevada desert for one week, Burning Man attracts artists and art lovers from all over the world. Yet few installations can surpass Karen's titans. Welded together in layers of recycled iron, steel and rebar; dripping flaming tears; or exploding fire from their chests, Karen's statues embody raw emotion in its most basic, elemental form.

Founder of Oakland's American Steel Studios, an industrial warehouse serving as an artistic haven and Burning Man dream factory, Karen Cusolito continues to build giants as massive as her imagination.

"The community that I had when I was growing up was distinctly different from what I've found at Burning Man. It's hard to describe, but the sense of what's possible is bigger when we're all supporting each other, when we're all collaborating, or when we're propping someone forward to achieve their goal. I think we all inspire each other, which is good and bad. Some of us don't need any more inspiration, but you can't help it. It's bouncing around out there wildly."

—Karen Cusolito

www.KareCuso.com

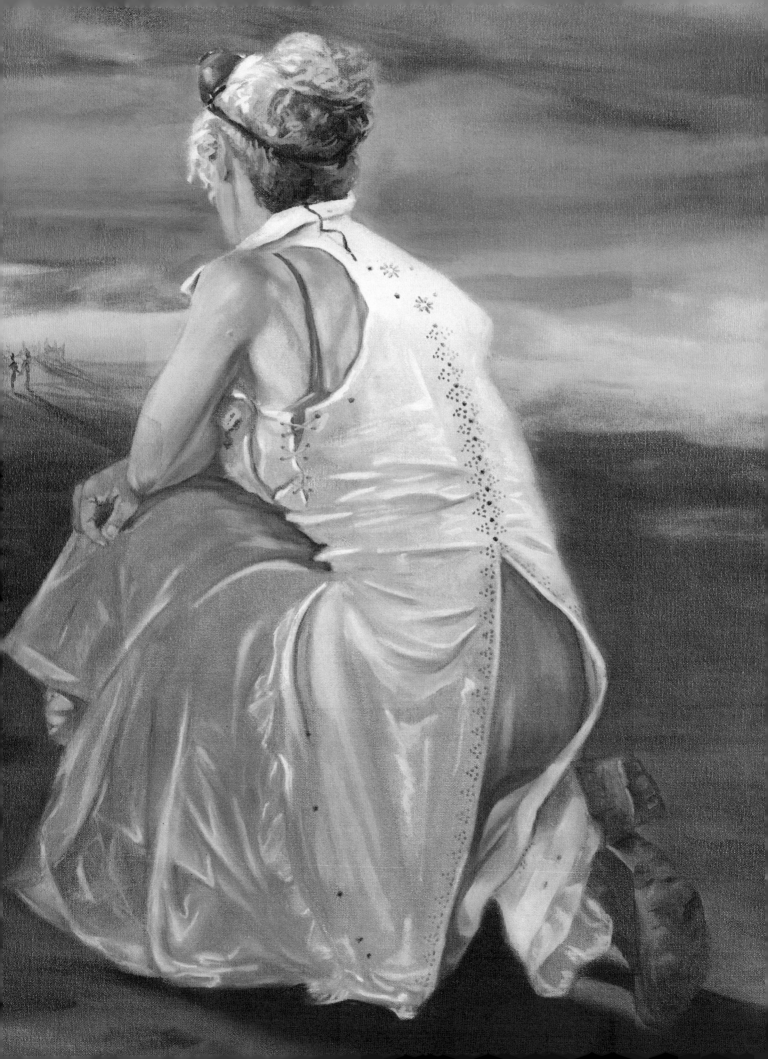

I remember coming back to Center Camp at Burning Man and seeing these large metal beings, one with a flaming heart, one with its hands on fire, and one bowed to the ground with burning tears. They took my breath away. They came out of nowhere. They were such a presence that everyone stood around staring at them. I especially connected to the one with the fire in its chest, because I had once painted an inner-landscape of my heart. It was a cathedral made of fire, on fire, with bright colors, orange and red. Every time the mechanical pump expanded, a whoosh of fire burst through the giant's scrap metal ribcage, rising up and illuminating the body from within. I believe it was called Epiphany.

Karen's statues have always made a presence in Black Rock City. There's an immensity to them, expanding until they're as big as our emotions feel. Out there, on the near endless plains of white dust, they stand like guardians: personifications of joy, praise, love, and lament.

Back in Oakland, I went to visit American Steel Studios. It's a giant industrial warehouse down by the waterfront—a studio housing 170 artists and small businesses under one six acre roof. The gates are guarded by steel monsters sitting atop thrones, and each bay holds a different mad man's workshop. Statues, art cars, floats, a wooden cabin, a tower-

ing puppet, a pedal-powered desert ship, all dreams in the making.

"It's interesting that this space has evolved in a way much like the playa has," Karen told me. "Given its size, a lot of people actually ride their bikes to the bathroom, for example. The different areas of the building have different disciplines, different types of work happening there, and they kind of become different camps in a way. So there are little micro-communities here, and then there's this amazing cross pollination and collaboration that happens. Because when you have all these people with different skills, even if they're from different camps, sometimes you need all those skills to come together to complete a project. And oftentimes, it then soars beyond wherever you really thought it was going to go."

While catching up with Karen, she showed me prototypes for her new project in Brazil, a set of giant, metal dryads extending their branches to each other. In so many of Karen's pieces I sensed a beautiful kind of integration, coming together like welded roots.

26

"American Steel Studios is in a challenged neighborhood," she explained. "I believe West Oakland has the highest concentration of foster kids in the Bay Area. So these kids are missing some really great opportunities, and we are doing our best to open our doors to them and allow them to learn some of what we know. That doesn't mean they're going to become giant metal sculptors, but it might just plant that seed of pride and confidence in them that allows them to do whatever it is they're going to do."

Karen is one of those beautiful, warm, intelligent people with a very deliberate message. She gets things done, and if it's in her way, she takes to it with a blowtorch to make art out of her obstacles. She's surrounded by a lot of amazing people, having achieved truly epic feats of creation with the help of her team. They support her, and protect her in many ways. Three of her dear friends Don Cain, Rebecca Anders, and Michelle Burke (left to right) were included in the painting, standing next to Manu, the Buddha-like titan of contemplation.

That's one of the reasons I picked Karen for my Burning Man dreamscape. A lot of times, when I describe the desert out there,

people instantly assume it's just one big party, and it is, but there's a whole lot more than that. It's a city of 50,000 people, bringing with it 50,000 visions. Healers, jugglers, soothsayers, anarchists, pyromaniacs, artists, the weird and the wild, the lost and the free, the scared and the hopeful. And what's so amazing to me is that, by leaving the mundane behind, people become more true to themselves, making a community based on the moment. There's a quiet, unspoken sentiment. Be you, your true self. Be now, in the real now. And there's a love in that, and a real freedom, I think. In that one week, absolute strangers can become like family, and family becomes even closer.

"Don't be afraid, just try it out. You're capable of more than what you realize. I think one thing that really holds us back is fear. 'You're doing it wrong,' is a phrase we hear a lot now. We say it because we hate it. I think part of the difference between the community I grew up in and the Burning Man community is that I *was* doing it wrong, because I wasn't doing it right in their eyes. And having that type of feedback growing up can impede your ability to just reach out and stretch as far as you can and just try whatever it is you want to try."

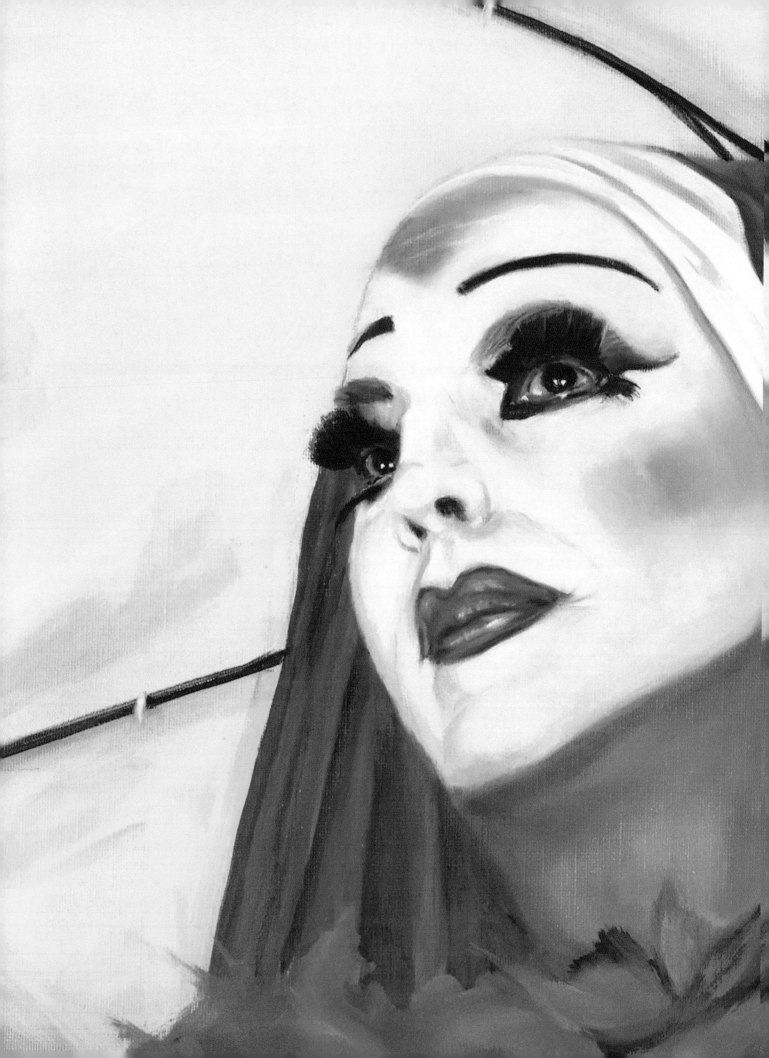

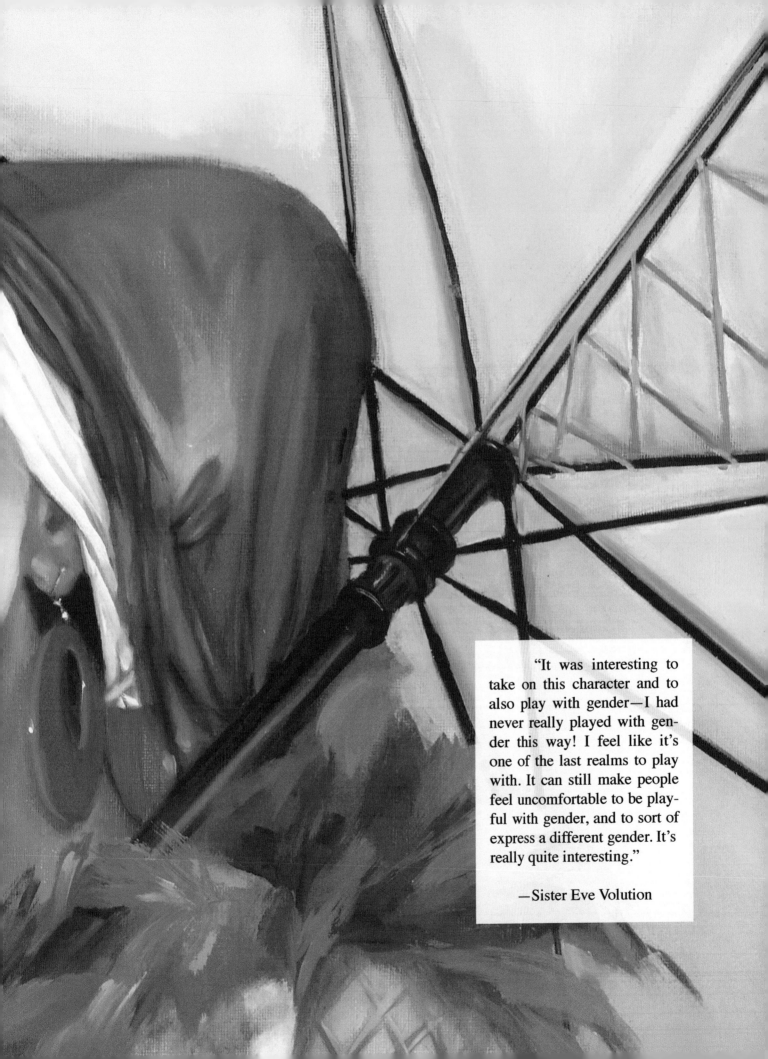

"It was interesting to take on this character and to also play with gender—I had never really played with gender this way! I feel like it's one of the last realms to play with. It can still make people feel uncomfortable to be playful with gender, and to sort of express a different gender. It's really quite interesting."

—Sister Eve Volution

Castro Madonna

Sister Eve Volution
Oil, Metal Pigment & Nail Polish on Belgian Linen
24 x 48 in.

Bursting out of the San Francisco gay scene circa 1979, the Sisters of Perpetual Indulgence began drawing attention to social issues via campy humor. With the impact of the AIDS epidemic, the Sisters became safe-sex advocates raising money for Lesbian, Gay, Bisexual and Transgender (LGBT) community projects.

As a fabulous drag heroine of the Castro chapter, Sister Eve Volution heads up the *Stop the Violence Campaign,* working with the Castro Community On Patrol (CCOP) and the San Francisco Police Department to keep their community safe.

Recently, Sister Eve Volution began work on the *Queer Refugee Committee*, collaborating with relocation programs such as the Organization for Refugee Asylum (ORAM) to provide friendly homes for LGBT individuals escaping persecution in Africa and the Middle East.

"We have Sisters who are religious, and we certainly accept Sisters from any religious background. We've got Wiccan, we've got Fairies, we have Southern Baptists, Catholics, Buddhists, Agnostics, Atheists, the whole gamut, the whole realm. However, Sisters are encouraged to develop a spirituality. It's not necessary, but they are encouraged to do so to figure out their path, and what path they'll use to, hopefully, minister to other people.

It's sort of a strange thing, you know? Ministering to other people can be just lending an ear when somebody needs an ear, or when somebody is under distress—just helping that person! It really is kind of interesting.

There have been times when I've been out, and you're sort of expected to become like a confessor. And I've had people come up and confess things to me, or just want to unload, and they really do look at you as this sort of spiritual, quasi-religious figure that won't be judgmental—who will hopefully make them feel better—and they can look at something fabulous while they're doing it!"

—Sister Eve Volution

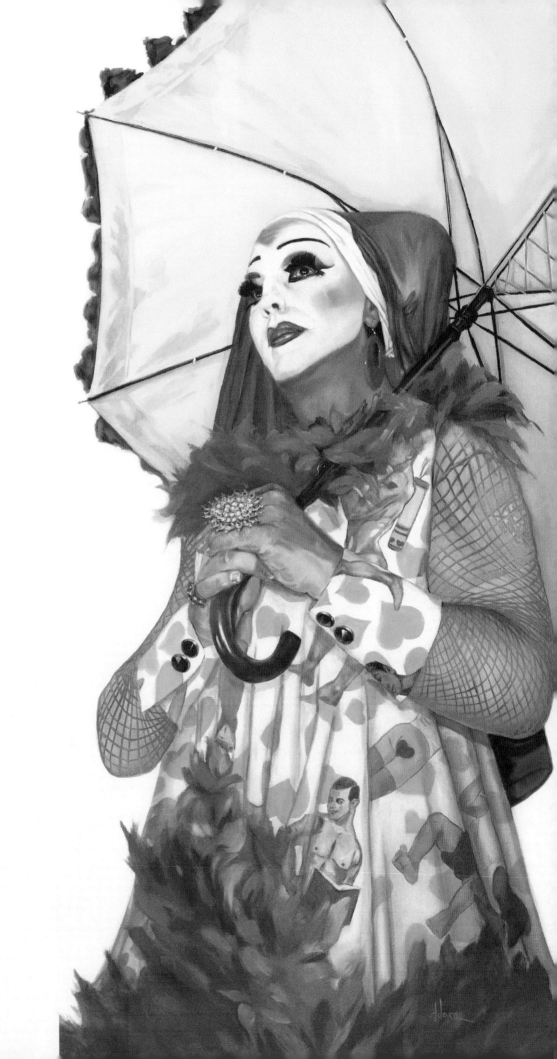

Mysterium

Kimberly Dark
Oil & Gold Leaf on Belgian Linen
12 x 48 in.

Lauded as one of the top six LGBT campus speakers by America's longest running lesbian and gay interest magazine *The Advocate* (2011), professor Kimberly Dark invites her audience through complex fragility to empowered strength.

Challenging the norms of sexual expression and gender expectation in storytelling performances like *The Butch/ Femme Chronicles*, *Dykeotomy*, *Complicated Courtesies*, and her ongoing show *Good Fortune*, Kimberly Dark is a feminist tour de force. Her keen humor and intense presence expand the art of storytelling, combining wit with empathic insight. Traveling from Australia to Germany and everywhere in between, her award winning solo performances deconstruct all preconceived notions of sex, body image, gender identity, and personal self-empowerment to inspire a new paradigm.

A blogger for the *Huffington Post* and *Ms. Magazine*, Kimberly Dark continues to teach Sociology at California State University, San Marcos.

"I think it's quite dangerous when people take on identities that can't change, because inevitably they'll be let down. We are constantly in motion, constantly changing—though most people do so fairly indiscernibly. So, in terms of the body in culture, I'm reasonably comfortable with labels such as female, femme, queer, fat, dyke, mother, parent, middle-aged, white, mixed race, scholar, activist, sexual, sensual, artist, mostly able-bodied, incest survivor, intellectual, writer, poet, and the list goes on. There is no hierarchy. The most important identity is always relative to one's company, one's deep yearnings and the responses one hopes to create."

—Kimberly Dark

www.KimberlyDark.com

"Freedom lies in structure; this is one of life's many paradoxes: the ability to recognize oneself as separate from others, from the world, and yet profoundly embedded in everything. We exist in relationship with everything and yet, we are profoundly sovereign. That's how a person breaks boundaries: by remaining sovereign.

Women are socialized to acknowledge relationship before self and this is out of balance, just as acknowledging self before relationship is for many men. Queer / genderqueer people sometimes emerge into greater balance; not always. At times, people say of me: "She doesn't care what other people think!" Or they think I mean to say: "Don't listen to what any-one says – that's how you become original." I wonder what a person sees in me to believe I don't care what anyone thinks. Perhaps this is the only way to see personal fortitude at first. And it's simply not true. Each of us is already "original." We have to learn and then work to hide that originality. Most people succeed brilliantly at carrying out the conformity of their socialization.

So do I. I am what my culture has made of me, and then in addition to that, I am what I allow myself to be, what I create myself to be in rela-tionship with everything I see and understand. In order to move beyond boundaries, we have to be aware that they exist. Power moves. It moves along pre-established lines like a freight train, every day, carrying all of the expectations and sanctions we've come to trust and loathe. Power also moves through us, around and within our interactions. With awareness, we choose when we will partner with power, or amass power or oppose power.

What makes it possible to choose? Awareness and practice. That's all. I care deeply what others think and feel, and I choose not to be defined by others. I care especially much for the views of those whom I respect and adore. I mold some of my identity to meet them. I can take in the input of the world, use what I choose, listen carefully and then act as a sovereign being.

Just as a sovereign nation is responsible for all that happens within its boundaries, responsible for its relationships with other nations, responsible for what it creates and withholds, so too, individuals can become sovereign. We are inextricably buoyed in the river of time and the matrix of cultural and physical geography. Sovereignty includes both freedom and connection. Personal sovereignty does not release us from responsibility the way conformity does. I bear a beautiful burden; so can you.

Do women have it harder than men? Yes, and we are all railroaded by social expectations. Mixed / third / transgender people have it harder still. Not because of anything within us, but because some groups are more likely than others to be persecuted and killed for asserting their sovereignty.

And that's why we need models of difference: joyful, fancy, fasci-nating, amazing models of sovereignty and relationship and awareness and freedom. Like the people in this book."

—Kimberly Dark

Bonnie Is Clyde

Billy Castro
Oil on Belgian Linen
12 x 48 in.

Born female in the American Midwest, Billy moved to California to become a happy hedonist, a porn star and a babe-worthy man. As one of the few trans-men in the porn industry, Billy works as a sex positive icon in the LGBT community, his x-rated films challenging every notion of conventional sexual identity.

The porkpie hat and suspenders are a reference to Billy's erotic detective flick *Speakeasy*, directed by indie porn producer Courtney Trouble of Real Queer Productions, winner of the 2010 Feminist Porn Award.

This particular portrait is featured in Europe's Porn Saints collective founded by artist Francesco D'Isa. As an art contingent spanning Italy, Germany, France and England, the Porn Saints celebrate sex positive porn stars via multiple mediums in contemporary and fine art. Inclusion of this portrait elevated Billy to the status of Porn Saint and Rose Adare to the honorary status of Porn Bishop.

www.BillyCastroFanclub.com

Artistically, *Bonnie Is Clyde* is my homage to Lucien Freud. The brush-strokes are thick, the dried paint scratched on the surface, giving the body a gritty, tangible feel. I usually paint quite thin, but Billy Castro has such a solid presence I wanted to give his painting a sense of gravity. The title, *Bonnie Is Clyde*, alludes to the criminalization of eroticism, and how so many trans individuals feel like gender outlaws.

While sexuality is found in art, there is a huge double standard: women can be sexualized, but are not allowed sexualities of their own, while men are allowed to be sexual, yet cannot be sexualized. This is obvious in portraiture. Galleries across the world exhibit beautiful, symmetrical, frontally nude women all the time, but a man with a hard-on is deemed rude, obscene, even comical — which is a shame since men are rarely allowed to be the subject of beauty.

Pornography has the potential to be the great equalizer. Unfortunately, it's filled with stereotypes. There's no plot, the sex is ABC, it has no real emotion, it's plastic, it's Hollywood. Often, independent films will touch on real people having real orgasms and real emotion which, for many, is the bigger turn on.

Independent pornography has also been a place for many sexually queer and gender-queer people to both explore and express themselves. It's a place where the social camouflage is taken off and people can get to the core of how they really feel, and express that to an audience.

In painting Billy Castro I wanted to confront out-dated censorship. He filmed a porn set in the 1920's called *Speakeasy,* inspiring the very concept. During that era, prophylactics allowed women sexual independence, yet the feminists of the Free Love movement were attacked by the Comstock Act, which indicted anyone who sent "smut" through the mail. If a magazine mentioned sexuality, it was pulled.

At the same time, prohibition drove the youth underground. Drinking and dancing in secret, they met the Beatniks, who would change their imaginations. And at the core? Sex. Sex as act, sex as expression, sex as identity. Ideas girls were never allowed to talk about, and boys were just expected to know without ever being told, were exploded.

When porn was finally accepted, it was controlled by vanilla heterosexuality, implying decent sexuality in one corner and perversion in the other. This shoved anyone outside the gender-norm into the dungeon. Since then, however, independent porn has shed new light on diversity. This is incredibly important—not just to expand people's horizons, but also for queer youth missing role models to compare their sexuality to.

Gender labels have been very limiting. Human beings are so much more than checkbox A or B, Man or Woman, and this creates a lot of dysphoria in people who don't feel like they fit in. Perhaps one of the most difficult parts about being outside the gender box is the lack of recognition. Since everyone begins their life with an anatomic sex, we all get labeled male or female, but gender identity expresses how much one feels like a man or woman, regardless of their sex. On top of that, gender expression then explains how masculine or feminine a person presents themselves. This creates beautiful diversity, especially for me as an artist.

When I first met Jiz Lee, the subject of my next painting *Borealis Bound*, I was astounded by their fluidity. They were beautiful, regardless of their sex, and because of the amalgamation of gender. While Billy Castro is a transgender-man working in the erotic industry, his presence is undeniably masculine. Jiz Lee, on the other-hand, identifies somewhere in the gender-queer middleground, preferring gender neutral pronouns such as "they" and "their."

This isn't a new idea, or even a modern social construct. Indigenous cultures have often had different words for queer, including the two-spirit, mahu, and fa'afafine. There is, however, a new shift in conciousness in our very understanding of what it means to be human, not just in our body, but in how we feel. We're being more accurate in our descriptions of self instead of sticking to old labels.

"People need this information. We've been hearing a lot in the news recently about the dangers of pornography, or youths looking at porn as

sex ed, or anyone who may look at porn as their only form of sex education. One of the reasons I value what I do is that I show an alternate way of having sex with alternative-looking people and alternative-sounding communications around it, instead of the only kind of porn you can see being ones with very particular sexual

language of what pleasure is supposed to be, who gets to have sex, what they look like, what is considered sexy. I'm a big advocate for conference of sex education, but unfortunately in this country people shy away from sex, and so, in its absence, we have pornography, and the easiest to hold up are the ones that don't exactly portray healthful sexual relationships, that don't talk about safety, don't talk about consent at all."

When Jiz and I talked about what we wanted to convey, it was the constriction of outdated ideas, and the claustrophobia of labeling, and how, for Jiz, that felt suffocating—even drowning. Simultaneously, *Borealis Bound* feels serene. The curled up pose is reminiscent of Gustav Klimt's *Athena*. There's a sense of building, pushing against the boundaries, yet there's also a surreal comfort. *Borealis Bound* is the antithesis of Millais' *Ophelia*. While Ophelia drowns in a world gone mad, Jiz Lee appears to rise.

"When I first started doing porn," Jiz remarked, "I had the idea that porn could change the world. Having a plethora of diverse sexual encounters that people could look to as examples, as inspiration. More varieties of helpful representations of sex. More different kinds of expressions of people who normally aren't the ones who are presented as being capable of looking sexy or being desired. That by having those examples, that could be educational or at least validating. That also can give people who are curious a glimpse into other people's lives. That if they were a part of sex education in a way that was inclusive of

gender and different sexual orientations and pleasure and communication and consent and everything, that you would have decreased sexism, and then decreased cis-sexism and decreased transphobia, and my hope is that it would, you know, cause more

nonviolent communication, cause people to be able to talk to each other in a way that doesn't cause disrespect, harm, poverty, the downward spiral that happens because we don't know how to talk to each other and love each other."

I think one of the most amazing things about Sex Positive culture in the 21st century is the unification of ideas. Researchers, academics, and sex workers are actually conversing at the same table, sharing ideas and life experiences to broaden our philosophical, sociological and psychological understanding of both sex and sexuality. Kinksters and sexual queers, who were once deemed diagnostic deviants, are beginning to publish papers of their own. Of some of the many voices contributing to the topic, I am a particular fan of Carol Queen's literature.

I first met Carol at the Amateur Erotic Film Festival on the Big Island of Hawaii. I was so enthralled that I stumbled over my own tongue and called her Carol King, to which she replied "No, I'm a Queen, darling." Hooked, I promptly flew to San Francisco to shoot her. The original model session was staged in the Center for Sex and Culture before its relocation. While I got to dress her up like a dandy (in my own red tie), little did I realize the plush red and gold headboard was actually infamous in its own right, being one of the featured props in Jiz Lee and Nina Hartley's exhibitionist onstage education Live Sex Show.

It's a small, kinky world.

Borealis Bound

Jiz Lee
Oil on Belgian Linen
12 x 48 in.

Jiz Lee is a gender-queer adult performer and sex positive icon breaking through the boundaries of the sexual, cisgender binary.

Winner of the 2010 Feminist Porn Award and Jan. 2014 cover model for *Curve Magazine*, Jiz Lee has been featured in over 200 international indie, and mainstream projects. As a guest lecturer at UC Davis, UC Berkeley, Mills College, Princeton, Evergreen State, Stanford, and the University of Toronto, Jiz illuminates sexually dynamic topics, covering everything from queer sex techniques to the ethical implications of pornography.

Writing about gender sexuality, and body-image, Jiz Lee has contributed to many publications, including:
The Feminist Porn Book (edited by T. Taormino, C. Penley, C. Shimizu and M. Miller-Young) and *Taking Sides: Clashing Views on Human Sexuality* by Ryan McKee and William Taverner. Recently Jiz compiled their own forthcoming anthology *How to Come out Like a Porn Star: Adult Industry Essays on Family Matters*.

www.JizLee.com

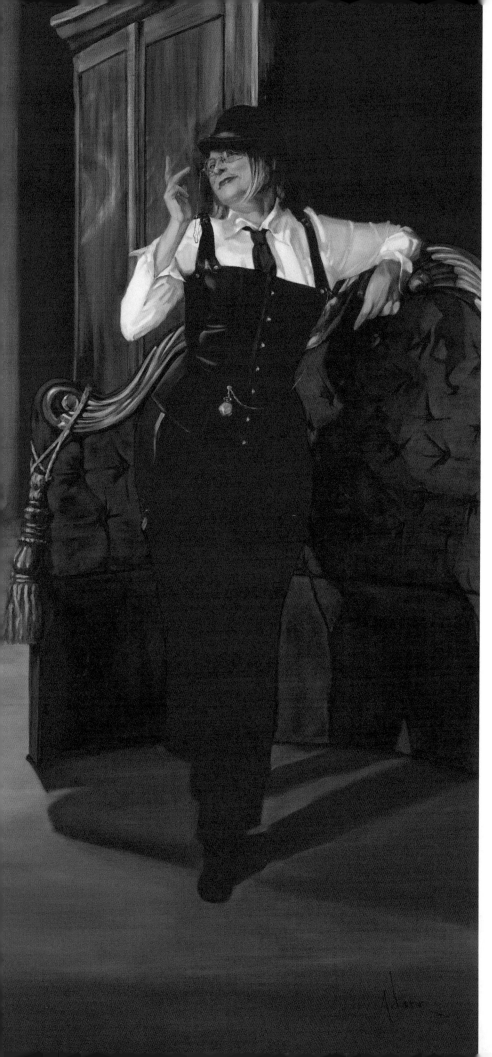

Queen Takes B4

Carol Queen
Oil & Gold Leaf
on Belgian Linen
24 x 48 in.

Part of the first wave of Queer Theorists, Carol Queen co-founded GAYouth, one of America's first gay youth organizations, before going on to found the San Francisco Center for Sex and Culture with her partner Dr. Robert Morgan Lawrence. And yes, she did some bisexual activism along the way, too!

Working as Good Vibrations'™ in-house sexologist, she is also a well-known writer. Her sex-positive literature includes *Real Live Nude Girl: Chronicles of Sex-Positive Culture* (1997), *Exhibitionism for the Shy* (1997), and *The Leather Daddy and the Femme* (1998); each is a must have in any sensual library.

Adding whole new words to the sexual lexicon, Carol Queen continues to expand society's understanding and acceptance of erotic exploration.

www.CarolQueen.com

"Know thyself is good advice, and many people haven't been given the background skills and information to know themselves... Who are they? What do they want? What do they fantasize about? When they masturbate, what do they think about? If they don't masturbate, get going, and figure out how you like to do it! And get the sexual energy flowing in your life so that you can figure out who the appropriate people are to share it with, and know that you will find those appropriate people, and you don't have to settle for inappropriate people. And that the optimization of sex is not the same for every person. And it's everybody's responsibility, if they want to get there, to think about who they are really. We don't just learn that from the culture. We get some notions. Maybe they fit, often they really don't. Just like it's your responsibility to decide what kind of food you want to order at the restaurant. It's maybe not quite as important a decision, although for many people it's really central to their pleasure and happiness. Saying it doesn't matter what you eat—of course it matters! And it matters how you have sex, and how you think about sex, too. I want people to get it—that this is such a deep core part of who we all are, and it's worth taking that seriously. This culture, in particular, thinks of sex as something that's endlessly interesting, but there! It's over there! It's not central, it's not integrated, and it's not an important part of how we understand fledging, and being ourselves, and going for actualization. But for many people that's exactly what it's central to."

—Carol Queen, PhD

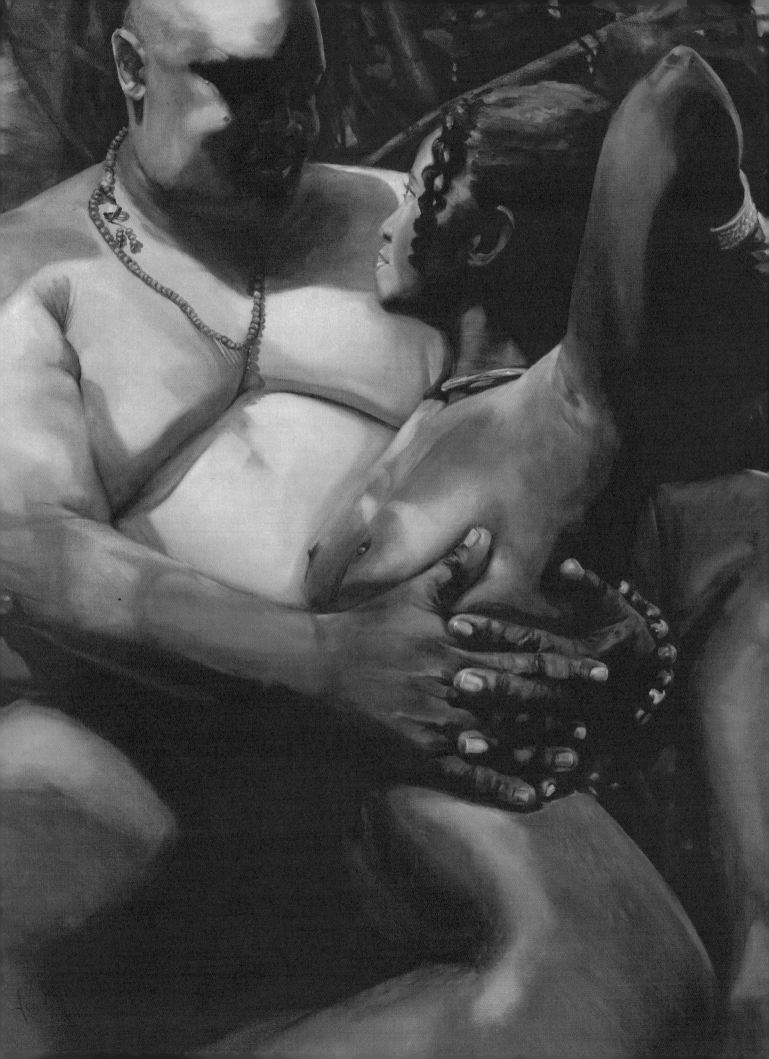

Genuflect

Richard & Namaste
Oil on Belgian Linen
36 x 48 in.

Born twelve years and 700 hundred miles apart, Richard and Namaste lived parallel lives; echoes of each other born in Chicago and Queens. Deeply involved in the church, they both skipped grades at school before being ordained as ministers, Richard at 15 years old, Namaste at 19.

Diverging from formal religion, their spiritual paths led them individually as life coaches and healers, each embodying and actualizing their corresponding energies before they even met.

Richard, in his authentic self, grew as a visionary, leader, priest, provider and protector. After spending many years as a guardian of diversity advocating on behalf of women, minority, veteran, and LGBT businesses in multi-million dollar corporations, Richard found himself coming face to face with his life's purpose: taking up the mantle of shaman, life coach and healer.

Namaste, in complement, spent years developing her core talents as well as being a mother, minister and business owner. Surrendering to a vision, she gives completely to the manifestation of the Will of her King as an acolyte, treasure and Queen.

Richard and Namaste present nationally to both alternative and mainstream audiences alike. Their popular seminars cover sustainable relationships, power dynamics, sexual fulfillment, and the divine self.

I met Richard and Namaste at a retreat in Hawaii. I was really curious since their classes included both sex and spirituality, and alternative power dynamics in relationships.

I was so amazed by how they related to each other that I had to paint them. This was a great pleasure since I was able to put to rest a deep seeded misconception I didn't even know I had. Previously, I had felt uncomfortable with seemingly imbalanced power dynamics. I assumed women who voluntarily submitted in relationships were weak willed, but I couldn't have been further from the truth. Namaste is very self empowered, and Richard's love for her is very palpable, so we let his grip be the corset. Very few people notice Namaste's hands are tied.

Relationships in which one partner willingly and consciously submits to the other are based on a level of trust, respect, and adoration. If anything, the Leader is truly responsible for their submissive partner, having to coordinate so many facets in their life while at the same time tending to their needs. Likewise, the submissive position is voluntary, and committed, almost agapic.

Power differential relationship dynamics aren't synonymous with sadism or masochism, though they're often complementary within the alternative sexuality community. In order to maintain a respectable and beneficial dynamic, communication is incredibly important, requiring every party involved to discuss their relationship on a level rarely explored in mainstream culture. It is a truly beautiful thing to actually talk through what we, as sexual beings want, and to be heard by another.

www.RichardAndNamaste.com

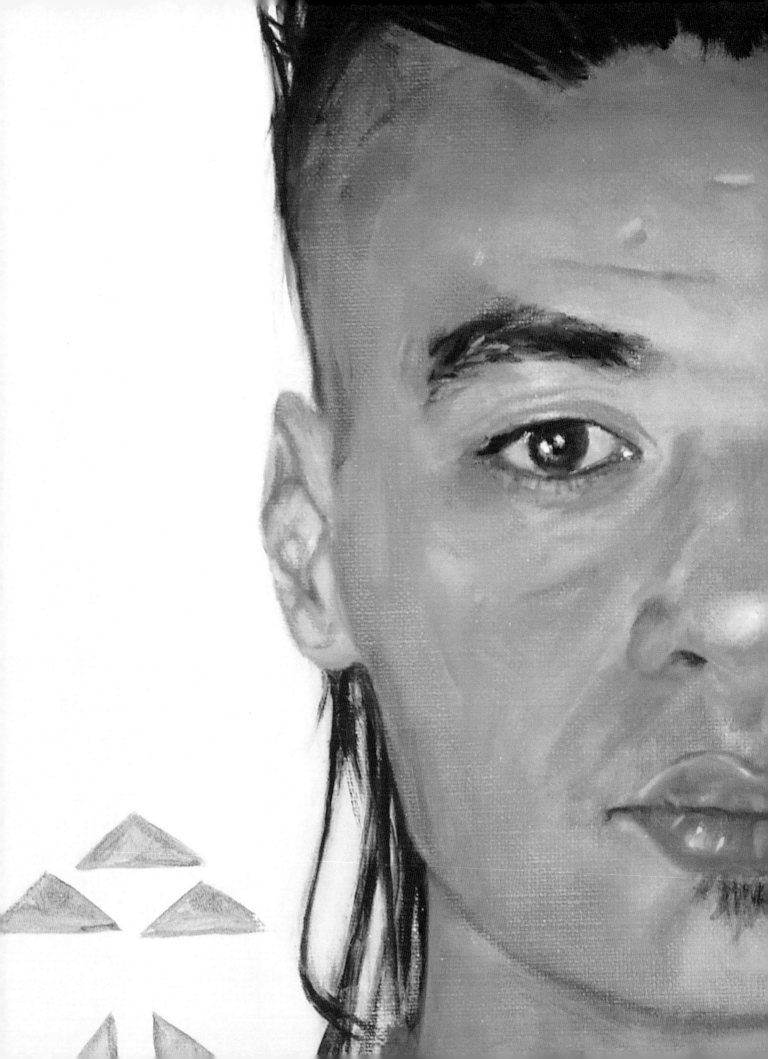

"Everybody's born with responsibilities to become a student and to become a teacher, to share what you've learned with others to help benefit all. In the sense of teaching culture, it's important to pass on the lessons and values needed to become stewards of the land. Through every action you do, you are a teacher no matter what. No matter how you talk, how you walk, how you dress—you are teaching the little ones. It's part of the cycle of life. Each person passes on a trait, leaving a ripple in this water. Being mindful of that, being conscious all the time in your life, no matter what, is important. We are all part of this together."

— Joshua Lanakila Mangauil

Talk Story

Joshua Lanakila Mangauil
Oil on Belgian Linen
12 x 48 in.

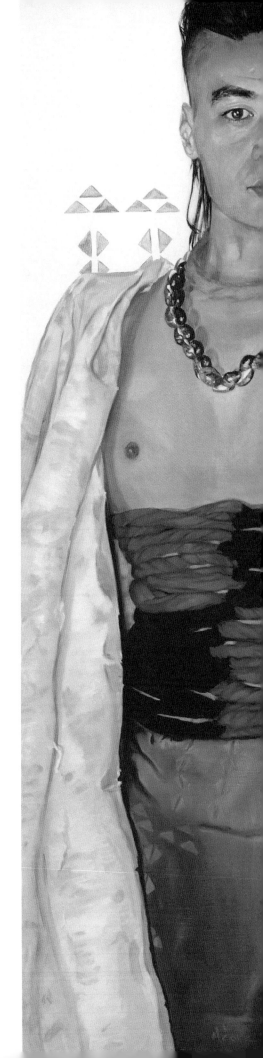

Born on the slopes of Mauna Kea, on the Big Island of Hawaii, Joshua Lanakila Mangauil spent his life balancing indigenous Hawaiian culture with the modern world. Learning the canoe plants, the rights of passage, and the ancient chants, Lanakila became both a student and a lifelong teacher of Hawaiian culture. Hired by the Waiakea Elementary School as part of Hawaii's cultural Kupuna program, he teaches youth about the 'Aina they walk on, and the gods and goddesses present in their everyday life.

Flown to Poland as part of his community group program E Ola Mau I Ka Pono, Lanakila helps individuals to reconnect with their own heritage. Rather than revere another culture's practices, he shows people how to connect with their elders, root out the medicinal plants, and relearn the ancient deities of their own land.

Protesting the further development of Mauna Kea's summit, Lanakila turns his eyes to the future of Hawaii's sacred sites, and what it means to be a warrior in the 21st century.

Lanakila's rope binding is modeled after ancient Hawaiian armor made from Hau cordage. Each twist in the rope represents another tradition, supporting the core to make the wearer stand straight and tall. Lanakila's mahi'ole, helmet like hair is inspired by illustrations of Hawaiian warrior-hair-cuts in European ship-logs, dated from the 19th century.

The lei hulu, or feather lei, given to Lanakila by a community elder, represents the fragility of wisdom, our connection to the heavens, and how feathers hold the birds aloft in the sky. His shell necklace is made from the kupe'e, a type of ocean-snail that burrows in the sand and emerges in the moonlight, representing our birth from the sea, our grounding to the earth, and the ability to take thought to a deeper realm. The fabric draped over Lanakila's shoulder is a traditional Samoan Kapa. Made out of native plants, its thick folds provide both warmth and protection on the summits of Mauna Kea, serving as a shield in the ceremonial realm, and a net to capture positive mana.

Sky Dance

Buffy Sainte-Marie
Oil on Belgian Linen
12 x 48 in.

As an Academy Award winning songwriter, Buffy rose to stardom in the 1960s folk music scene.

Born on the Piapot (Cree) Reserve, in Saskatchewan, she was adopted and raised in Massachusetts, where she grew up, earning a B.A. in Oriental Studies and later a Ph.D in Fine Arts. As a young adult she was reunited with relatives at Piapot and taken in as family.

As both a proponent of alternative conflict resolution and the guitar of the Native American Red Power movement, she became an iconic role model, providing one of the few genuinely accurate depictions of Native American culture in the media.

Blacklisted from media airplay by Lyndon Johnson and Richard Nixon for her outspoken defense of Indian lands, in 1974 Buffy became a regular on *Sesame Street*. In one episode, Buffy became the first woman to breastfeed her baby on television, reaching families in 72 countries around the world.

With her concert monies, she initiated the Nihewan Foundation, whose educational Cradleboard Teaching Project brought Native American science, social studies and other core subjects into public education. An internationally exhibited pioneer in digital art, Buffy also teaches visual arts and digital music in several universities.

Her song "Up Where We Belong," performed by Joe Cocker and Jennifer Warnes in the classic movie *An Officer and a Gentleman*, won the BAFTA Film Award for Best Original Song, a Golden Globe, and an Oscar. In 1997, Buffy's variety special *Up Where We Belong* also won the Canadian Gemini Award, while Buffy's full career received the Governor General's Performing Arts Award in 2010.

Following up her award-winning 2008 CD release of *Running for the Drum*, Buffy is currently recording her twentieth album. She continues to sing on tour, her powerful message calling for a peace so often forgotten.

When people think about the Occupy Movement they recall the tear-gassed eyes on Wall Street, but the power of pacifism has a long history. In 1969, a group of 89 Native American men and women, called the Indians of All Tribes, converged on Alcatraz. Citing a treaty with the Sioux, charted in 1868, entitling Native Americans to unused Federal Property, they camped out for 19 months until June of 1971. Creedence Clearwater bought them a boat named the Bass Tub I. Anthony Quinn, Jane Fonda, Candice Bergen, Merv Griffin, Jonathan Winters—all chipped in, and Buffy Sainte-Marie, the musical voice of the Red Power movement, donated proceeds from her concerts to provide water.

Many years later, when I was studying at the San Francisco Academy of Art, I ferried over to Alcatraz for the Sunrise Ceremony on Un-Thanks-giving morning. I remember the chants, and how cold the air was, and the warmth of everyone huddled together before the dawn. Everyone was in awe. The dancers were beautiful, powerful, with so much emotion passing by their faces. They were ferocious, and gracious, and free.

Wherever I've lived I've tried to honor the land and people, chanting aloha with the Kahunas atop Mauna Kea, or singing Maori prayers in the sweat lodges. I found my roots in Ireland, going back before Christianity to the old forests, and I have a deep connection with that. I experienced déjà vu the entire time I was there. It was like being in a waking dream. But I think many people are very lost, and I meet a lot of wandering kids around the campfire. They exist without a past, or a connection to the Earth. And I see them drawn to indigenous cultures, even if it's not their own, like Gauguin to Java, or Mark Twain to Hawaii, or Nikolai Fechin to the snow of Taos, New Mexico. There's something real and substantial in tribalism. It's as clear as the sky and as solid as the ground.

When I started *Restraint & Revolution*, I began with artists and activists connected with both marginalized cultures and resistant cultures. By connecting heritage to modern identity, a new form of expression is created, combining wisdom with invention. It's wrong to say that these visionaries are ahead of their time. Buffy Sainte-Marie continues to rock. Her album *Running for the Drum* calls out blatant corporate greed in her song "No No Keshagesh," just as her protest song "Universal Soldier" called for peace at the start of Vietnam. Yet these sentiments of connection are as old as the land, and the spirit of her message is truly universal.

I first reached out to Buffy when I learned she had a home in Hawaii. She was not only very receptive, but incredibly insightful, having a background in Fine Arts herself. The image was so natural, so instinctual, being one of the first painted of the *Restraint & Revolution* series.

The stars in the background are the Triffid Galaxy, a favorite of mine of all the constellations because it looks like an eagle wing, honoring the eagle feather tied in her hair. The symbol of the Great Spirit, Eagle cuts between light and dark, summer and winter.

I love that she was the universal figure, and to me that's befitting.

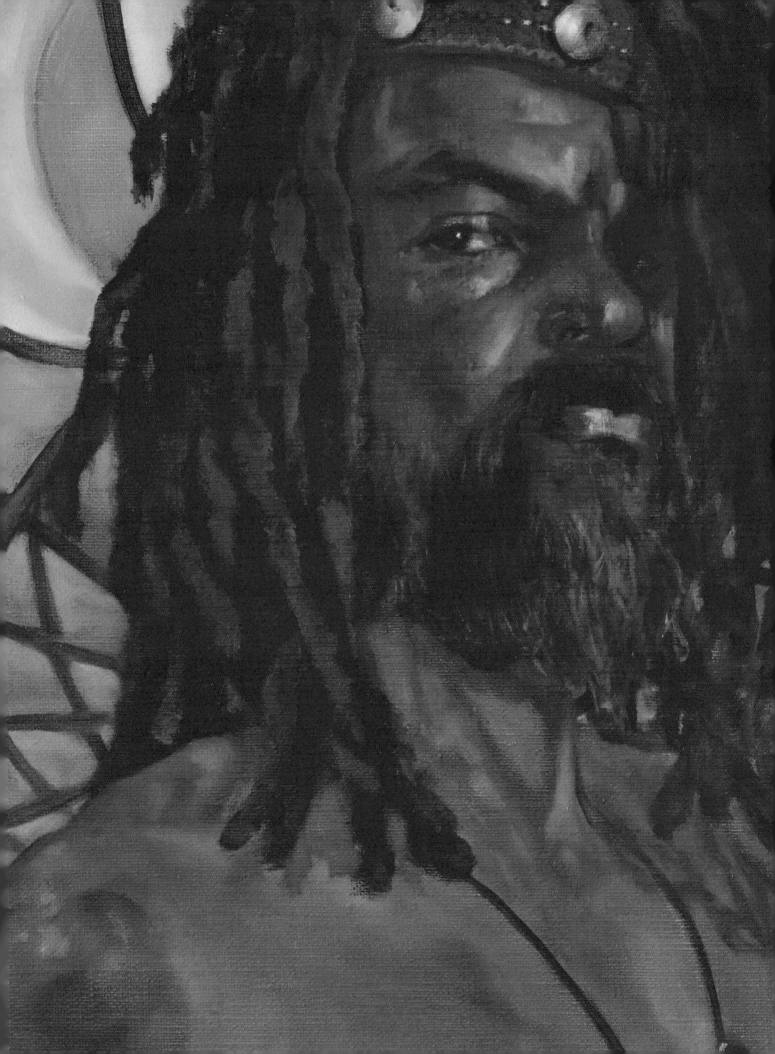

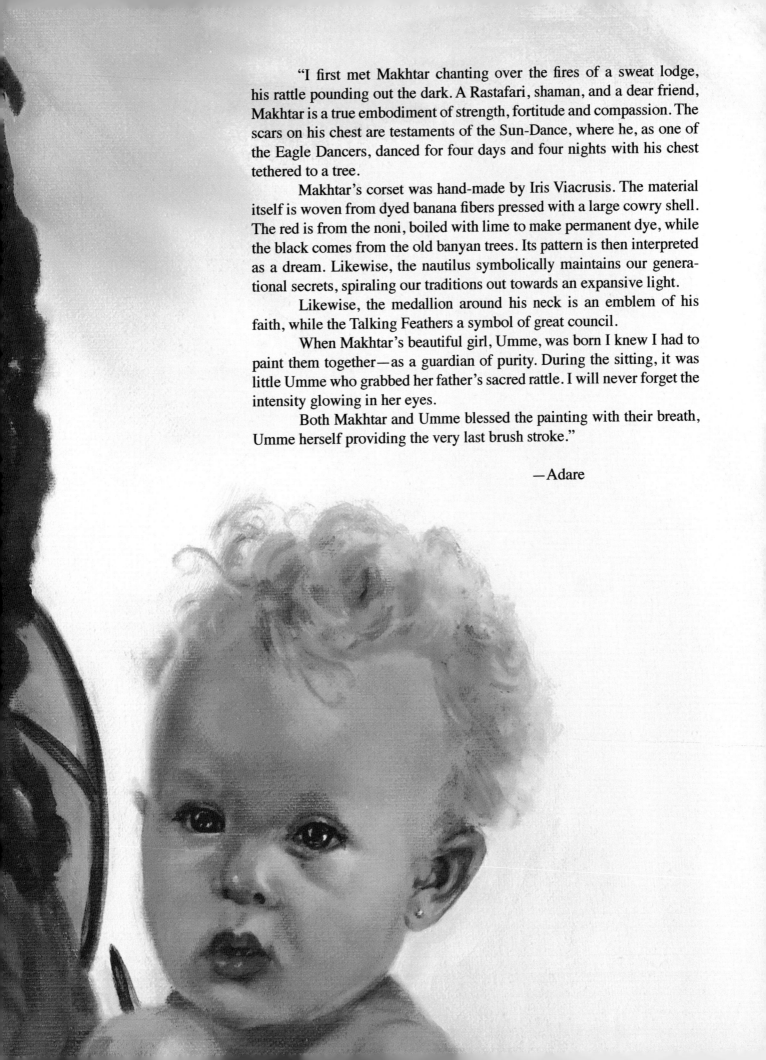

"I first met Makhtar chanting over the fires of a sweat lodge, his rattle pounding out the dark. A Rastafari, shaman, and a dear friend, Makhtar is a true embodiment of strength, fortitude and compassion. The scars on his chest are testaments of the Sun-Dance, where he, as one of the Eagle Dancers, danced for four days and four nights with his chest tethered to a tree.

Makhtar's corset was hand-made by Iris Viacrusis. The material itself is woven from dyed banana fibers pressed with a large cowry shell. The red is from the noni, boiled with lime to make permanent dye, while the black comes from the old banyan trees. Its pattern is then interpreted as a dream. Likewise, the nautilus symbolically maintains our generational secrets, spiraling our traditions out towards an expansive light.

Likewise, the medallion around his neck is an emblem of his faith, while the Talking Feathers a symbol of great council.

When Makhtar's beautiful girl, Umme, was born I knew I had to paint them together—as a guardian of purity. During the sitting, it was little Umme who grabbed her father's sacred rattle. I will never forget the intensity glowing in her eyes.

Both Makhtar and Umme blessed the painting with their breath, Umme herself providing the very last brush stroke."

—Adare

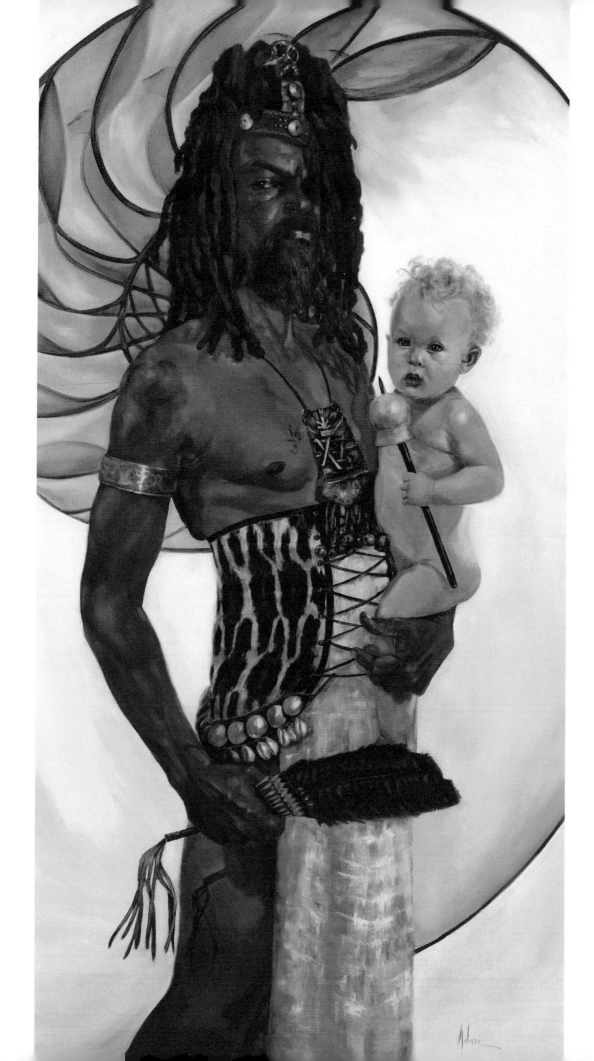

Fire In Steady Hands

Makhtar & Umme Mbacke
Oil, Gold Leaf & Peyote Medicine Varnish on Belgian Linen
24 x 48 in.

"Everybody's life is Rasta. Everybody has dreadlocks. Whether you try to use combs, straighteners, cut them—as soon as you put that scissor down, or that straightener down, your hair is dreading up again. Your beard is growing right back, but you keep cutting it. You have to be dutiful. But everybody is dread. It's the natural state. And everybody's Rasta because it means righteous. Everybody's trying to be righteous. Everybody's breathing. That's why you know you are a Rasta, because you're breathing the breath of life. And we're all on this planet in paradox. There's got to be a Babylon and there's the Rastas—its got to be! It's got to be like that…but we're all Rastas.

I was born in Greensboro, North Carolina, April 5th, 1958. I left Greensboro when I was 18. I was hitchhiking to Jamaica, growing out my dreads, and I got stopped on Daytona Beach. Then I came back to North Carolina. Got a ride from my brother who had a stolen car, and we drove all the way to Venice Beach. I didn't know it was stolen, but I found out. And we got to Venice Beach, and I got in a band, and I started playing for my breakfast, immediately. I toured the country with the singer H.R., then I came to Hawaii for a three week vacation. The band was getting ready to go to France, and I didn't leave, so I'm still on my three week vacation! But I've been to Africa twice, Mexico, to three Sun Dances, and had five children.

My name, Makhtar Mbacke, means 'Chosen Prophet.' You have the prophets and you have the Makhtar: 'Chosen.' I was named Makhtar in Africa on my first visit. Then I went to the Holy city of Touba and got Mbacke, my last name. I met Muhammad Mbacke, the grandson of Sëriñ Touba. Sëriñ Touba defied the whole French army, and the only weapon that he used was that he never got angry, and they could not kill him. And I met his great grandson. It was a very special day.

If I had to tell the next generation one thing, it would be this: Love Jah. Love yourself. Without you, there is nothing. Without everybody, in their place, there is nothing, because the Lord has given us the breath of this planet. So never get lost with the money. Never get lost with the city. I always feel like we're coming from this: Farming, Organic. That's real. These are serious times. There's no guessing about it now. Everybody sees the pollution. The pollution in the world. The roads are covering the Earth like a web. And these roads are the web, and we can't farm on these roads. And then, on the roads, we're driving these cars everywhere. Making better roads—that's the whole thing—making the roads better than the earth. But even with the sun shining on these roads, you can see the vapor coming off these roads without anything even driving on it. All over the world, these vapors are coming up into the ozone. So we have to farm, and we don't even have to plant anything. Just let the stuff that's going on already grow, and it will help our planet. That's the thing—help the planet. That's the job for us."

—Makhtar Mbacke

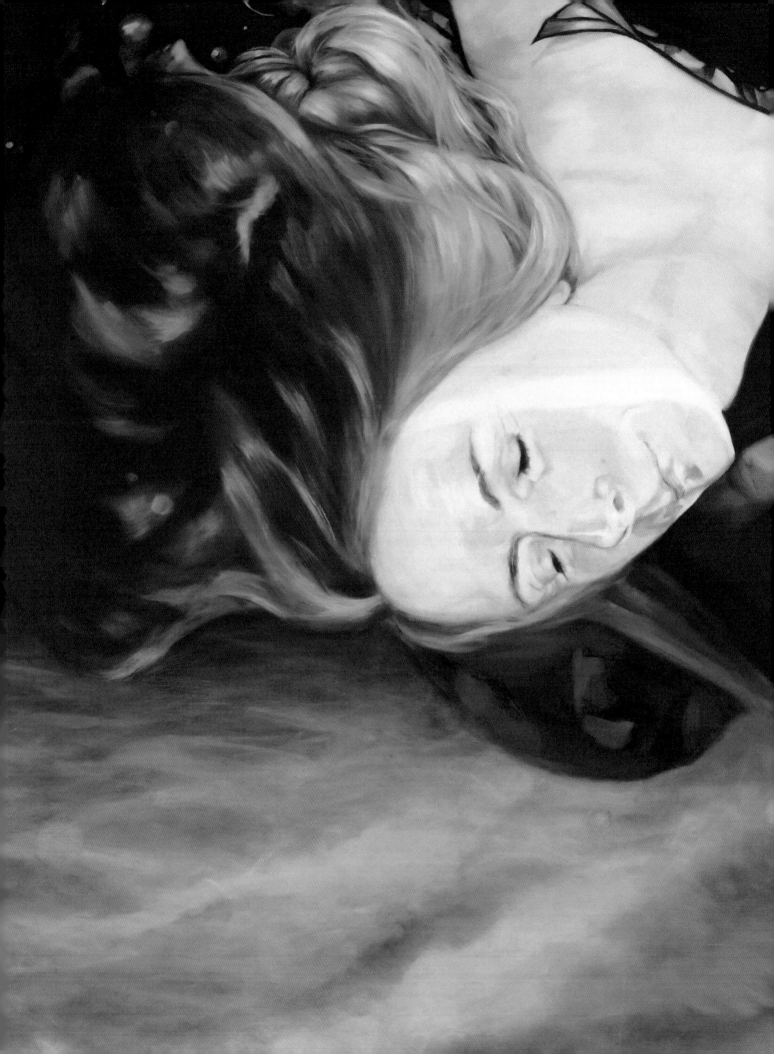

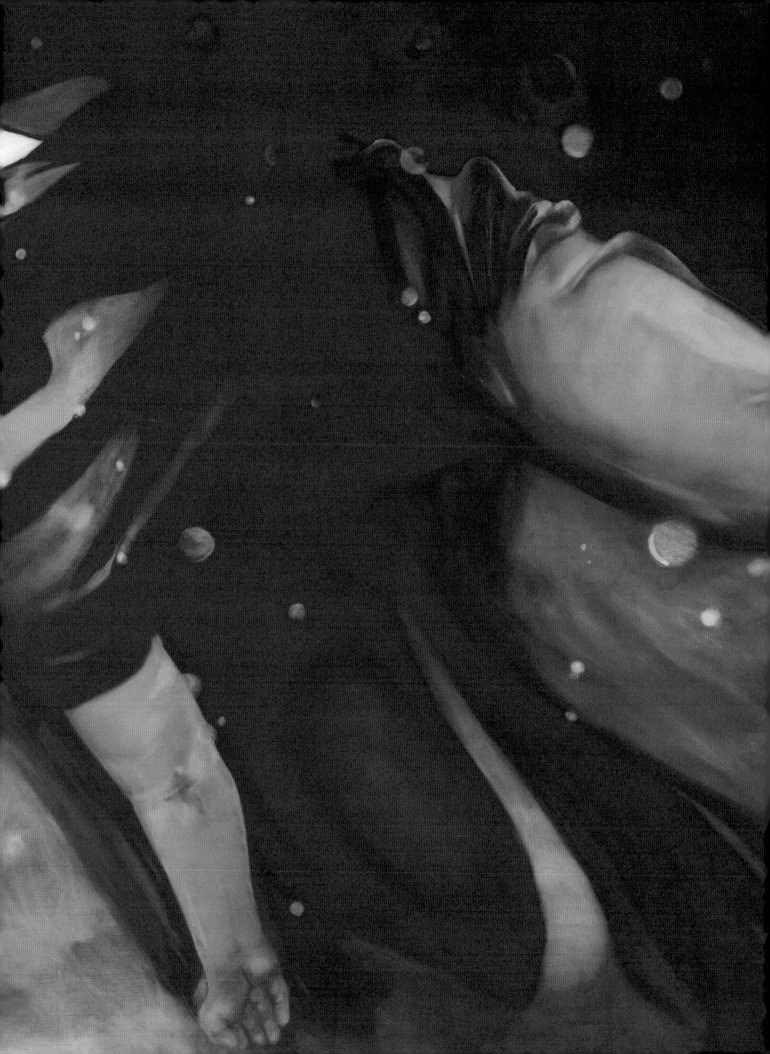

Lilia Cangemi
Oil on Belgian Linen
90 x 126 in.

Born in Milan, Italy, Lilia was barely five when she knew she wanted to follow her bliss as a dancer and a healer. Studying ballet, modern dance and mime, Lilia began teaching dance at 16.

After six years of Medical School she earned a Master's in Journalism, always searching for new ways to soothe and integrate body, mind and spirit. Intuitively, she wanted to combine holistic methods to access and ease the pain underneath the symptoms. Her exploration brought her to live in Mexico, New Mexico, Colorado, California and Costa Rica. There she studied and practiced shamanism, energy psychology, breath work, psychosomatic medicine, and aquatic bodywork. She became a Licensed Massage Therapist and with her experience as a Healing Dance, Waterdance and Watsu therapist and instructor she founded Dolphin Dance.

An eclectic art, Dolphin Dance includes multiple expressions. In the individual session the therapist massages the passive receiver on the surface of body-temperature water and then brings them underwater to immerse them in a prenatal and womb-like environment. The Pod Experience is a group activity combining partnering and intuitive movement accompanied by underwater music, leading the participants to ecstatic states and a unique sense of communion with self and the cosmos. Alternative sessions include activity and interactivity with multiple givers and receivers, sub-aquatic contact improvisation, and special sessions to heal post-traumatic stress due to emotional and physical issues.

Lilia has been living in Hawaii since 1998, enjoying her passions in the Big Island's splendid nature, while working in private practice and teaching internationally. Creating multi-media performances for theater and television as a producer, director, choreographer and professional dancer, she continues to teach and perform aerial dance, partner acrobatics, contact improvisation, and aquatic dance.

"Burst forth from your cocoon and fly, my beloved! Spread your wings and dive into the essence. For the journey itself is the destination. So let's welcome joy and pain both as our precious teachers, and be grateful for the grace of being, the eternal adventure of life".

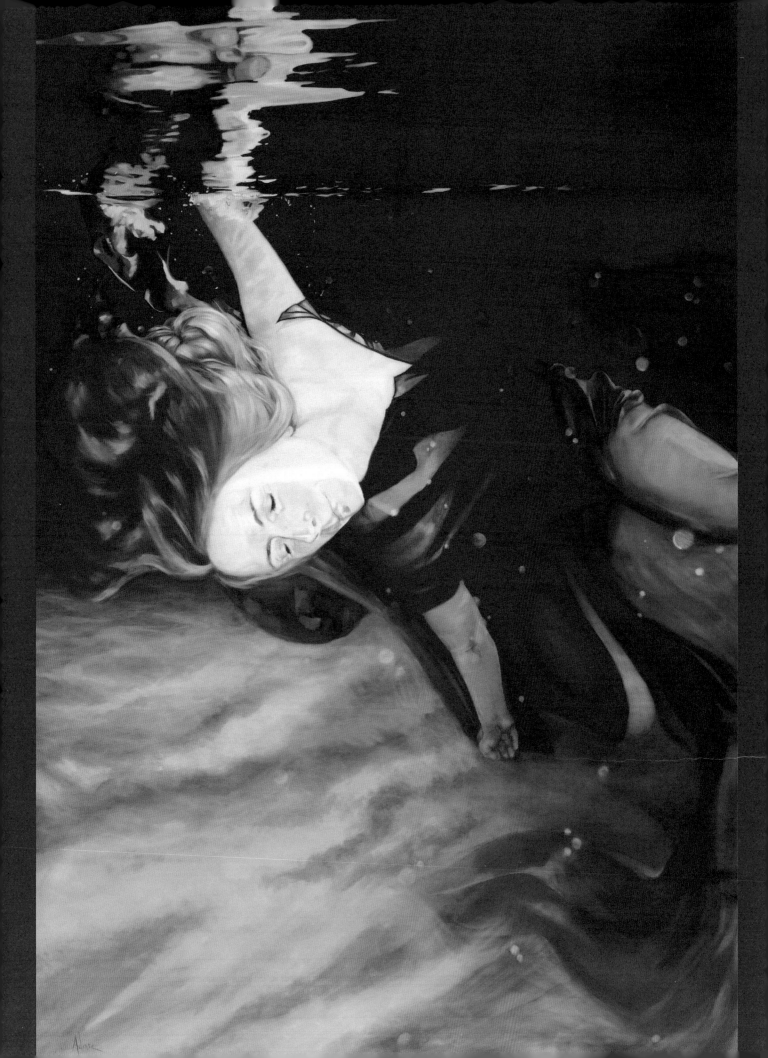

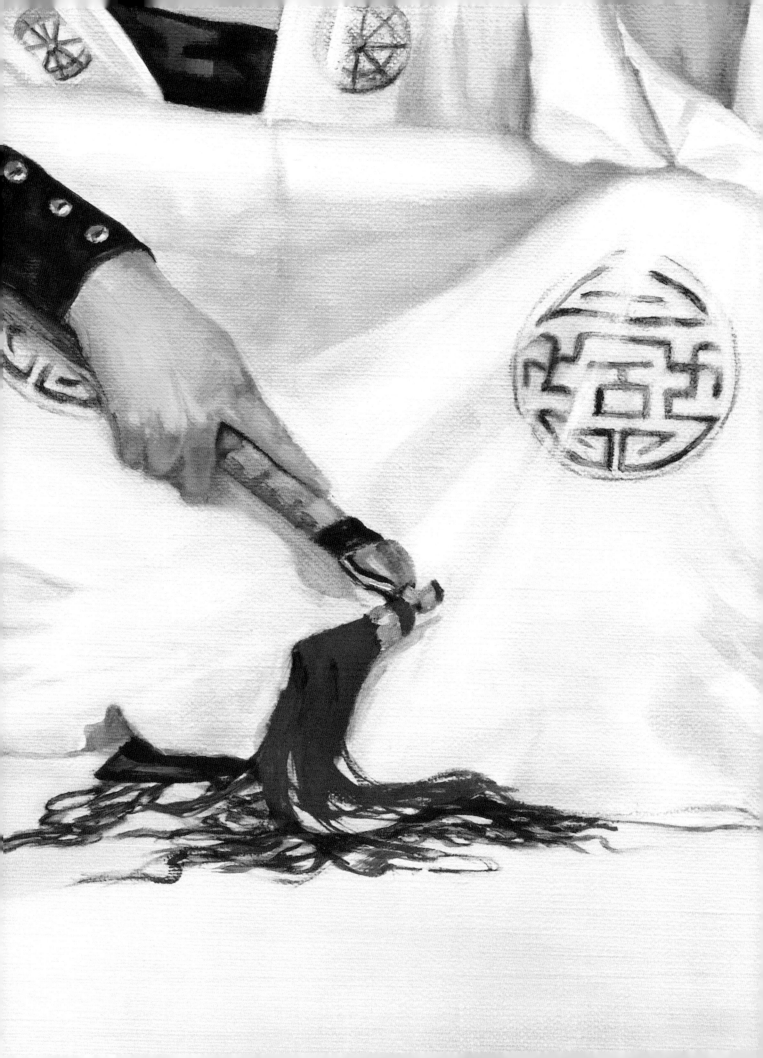

Edge

ying
Oil & Silver Leaf on Belgian Linen
24 x 48 in.

ying is both a past life incarnation and guiding force in Amy's life. Working as a practitioner of Chinese Medicine, acupuncture and the healing arts, Amy keeps ying even closer than her sword.

From the dusty canopy of HeeBeeGeeBee Healers, Burning Man's alternative medicine camp, to various clinics in Berkeley, Oakland, and Saratoga, Amy Chang LAc, CKTP, combines ancient medicine with evidence based practice, all while working to unify the spirit with the body.

"I first saw ying at Burning Man. At the healing tents people are strewn all over the ground meditating and moaning about their aches and pains. Then this woman appeared, gliding around the sleeping and the restless, with a sword poised like a folded wing. She never went anywhere without it. As far as I know she still doesn't. But there was this light around her. She shone, and I knew I had to paint her. The robe is a male acrobat's, originally bound by the black sash and criss-crossing rope. In ancient China, the ties and knots were traditionally worn under the clothes to keep their flowing outfits from coming undone. In this portrait I wanted to show a sense of serenity, of unfolding peace, while at the same time portraying the very masculine essence of Amy's past life."

—Adare

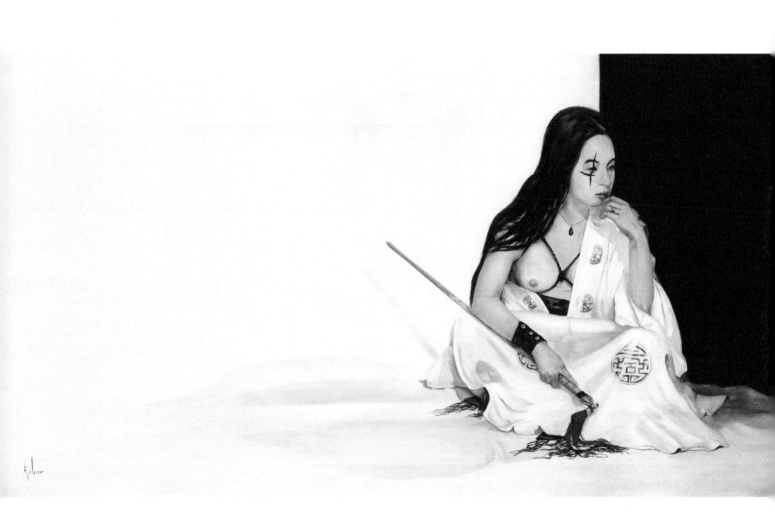

"Whilst Life Lasts In Me"

Blair
Oil & Hemp Oil Varnish on
Belgian Linen
24 x 48 in.

Born in Beverly Hills, Blair journeyed to Poitiers, France, as a teenager to join the convent Unión Chretienne de Saint Chaumond. After dedicating her life to the church, she fell ill. When the nuns told her to pray for good health, she was forced to escape out the window in search of a hospital. In a fever dream, Joan of Arc told Blair to don armor, so she returned to the U.S. to enlist in the Army.

During a tear-gas exercise, Blair's body shut down, being allergic to an agent in the gas. With her bladder and bowels in disrepair after seven surgeries and countless medications, her physicians prescribed marijuana, something an ex-military-nun had never tried.

Taking their advice, she found cannabis to be the only medicine capable of relieving pain without putting her in a haze. Emboldened, Blair now campaigns against the cannabis prohibition as a Hempetarian activist, professing the many uses of hemp while working in agricultural education at the Wageningen University in the Netherlands.

Food For Thought

Tiberio Simone & Yuriko Miyamoto
Oil & Metallic Pigment on Belgian Linen
36x48 in.

In a hot kitchen in Neviano, Italy, Tiberio Simone grew up watching his mother and grandmother cook and create edible and delectable magic. As a young man, Tiberio joined the Italian Special Forces, serving as part of an elite paratrooper unit. Yet the spice of life had taken hold of Tiberio, and he soon found himself in Seattle, Washington, working as a pastry chef. His culinary talents were quickly recognized, earning him the James Beard Foundation Award in 1995 for his excellence in the culinary arts.

Yet something was amiss in America. The average American's relationship with their food seemed as unhealthy as their relationship with their bodies, making the typical nutritional value of most meals as low as their self esteem. Like so much of life, food is a sensory experience, so Tiberio set out to heal the connection between food and body, health and sensuality.

Serving artistic edible arrangements with all manner of delightful volunteers as his human plates, Tiberio reintegrates the dining experience with truly fascinating dinner conversation. What is beauty? What is health? What is self appreciation? What goes well with strawberries? His new book *La Figa* (2011), photographed by Matt Freedman, features not only recipes, but page after vibrant page of Tiberio's models, dotted with chocolate tattoos or adorned with cucumber corsets.

Award winner of NARAL's (National Association for the Repeal of Abortion Laws) Chocolates for Choice, Chef Tiberio Simone continues to donate both time and food to charities, fundraisers, and artistic events via his own company: La Figa Catering.

www.LaFigaProject.com

Tiberio's model, Yuriko Miyamoto, is a Japanese artist transplanted from Tsuchiura-shi, Ibaraki, Japan to the States. Traveling and living along the West Coast from L.A. to Vancouver, B.C., she currently lives in Seattle, Washington. Her carefree, cartoon style layers the childlike catharsis of simple emotional imagery in thick acrylic paint. Inspired by her childhood in Japan, Yuriko observes how people bond with character icons throughout the world, almost as a way of connecting with themselves.

Capturing moments of kawaii fantasy, her paintings shift from the concentric halos of an Angel Octopus, to the swirling thoughts of a Smoking Monkey, to the flight of Super Dog. Yuriko's vibrant exhibitions, *Crossing Boundaries* (2008), and *Character And Me* (2012), were both featured at Seattle's Form/Space Atelier. By removing detail and keeping humor, Yuriko's colorful creations continue to connect with people across cultures by reminding everyone to smile.

www.Ysquare.net

Gregangelo
Oil & Gold Leaf on Belgian Linen
24 x 48 in.

A Lebanese-Mexican-American born in Chinatown, San Francisco, Gregangelo quickly took to the Mediterranean dance circuit, performing North African and Middle Eastern folk dance. As a teenager, his choreographer introduced him to the Egyptian style of the Whirling Dervish.

Combining the arcane with the secular, cosmic contemporary, Gregangelo performed in Cirque Du Soleil's *Solstrom*, alongside such Velocity Circus originals as *Heliosphere: an Adventure through our Solar System*, *Ekara: The Egyptian Journey of the Soul*, and *1906: A Journey Through the Mythical City (San Frantasia)*.

Lecturing at TEDxYouth, he challenges the expectations of beauty with artistic, interactive, community-based innovations, even transforming his home into the Gregangelo Museum—a multi-media sensory work of art complete with portals, passages and secret rooms exploring the profound beauty of existence.

As the founding artistic director of Velocity Arts and Entertainment, Gregangelo marshals over 100 specialty performers and artists. With such amazing artists in his orbit, Gregangelo produces private extravaganzas for many notable corporate giants, along with public programs and installations for Fine Arts Museums, fairs, festivals, and private commissions.

"The whirling Dervish, the motion of spinning, imitates the basic building blocks of everything, of how the cosmos is built, from the subatomic particles that are spinning, to our circulatory system, to the atoms in all materials, to, on a larger scale, the planets, the stars, the solar system, the galaxies, and possibly—and probably—the universe itself. By imitating it, you figuratively, and literally, become aware of your actual place in the universe, of how the structure of it works. It would be grand if we could answer all the mysteries in the universe, which will never happen in this conscious body, but it sure is fun to try. So I think that the Dervish is what it's about. And that act is well suited to me because, as a child, I was always obsessed with contemplating what we call the mysteries of the universe, which really aren't mysteries: they just are. We just don't know what they are. So every time I perform that act, or think about it, or work on a costume for any act, it always has something to do with our relationship to what I call the natural world around us."

—Gregangelo

www.Gregangelo.com

Paradise Lost

Amelia Mae Paradise & Sarah Paradise
Oil on Belgian Linen
36 x 48 in.

"When Sarah and I married in October of 2006, we chose Paradise as our new familial surname – we wanted to invoke pure joy for our partnership ahead. And joy we lived as two women united in love and creativity, dedicated to a daring, silly, exuberant expression of ourselves, best typified by our 'fashion friendly' wacky style sense. We made friends wherever we went because, literally, our outfits made people smile."

Together, Amelia and Sarah built a diverse and gender bending fan base as the Bay Area's bearded ladies of Diamond Daggers burlesque (a queer cabaret company Amelia started with her friends in 2002). In 2005, Sarah, who had already made a name for herself as Mr. Trannyshack (2005) and the lead vocalist of the punk-rock garage band *Dyspecific*, joined the Diamond Daggers as the Rambunctious Sir Loin Strip. As bearded women in a satiric, vaudevillian comedy dance troupe for the queer and fabulous, they flipped expectations upside down, dancing throughout the Bay Area, North America, and Europe.

"About a year after we posed for Rose's corset painting project, I heard from Rose that she was having a challenging time 'finding us' in the painting. She couldn't see Sarah's face, and was having an emotionally difficult experience of the portrait. I shared with her that Sarah and I were in the process of breaking up – having our own emotionally painful experience, too. And when I look back at those years of evolution, both of the painting and the people, I see the way in which Rose's process and ours were linked without us even knowing. It's clear to behold in the work itself and the lives lived that there are many dimensions to the act of creativity, more than we can ever comprehend."

In San Francisco, Amelia is still working as a radical feminist performer who spends quite a bit of time reading and meditating. In Oakland, Sarah still works as a radical feminist performer who spends quite a bit of time laughing with her dogs and her friends.

"We are both constantly in the generative and creative process of knowing ourselves more and reinventing ourselves anew. When I spoke to Sarah last she reminded me: Paradise has not been lost. Paradise lives in San Francisco and Paradise lives in Oakland. Though we are no longer the married women vanishing out of Rose's painting, we are still here, meaning there is more Paradise shared in the world now."

I love to paint dancers, contortionists, and theatrical-vaudevillian-circus-performers because of their expressive line of action. I also love how cheeky it all is. I love the comedy, the exaggerated emotions. We either walk away with a smirk, or thinking about our own past lovers. It touches us in a way we don't always register, and burlesque has a long history from the CanCan girls in Toulouse Lautrec's sketchbook, to the female impersonators of vaudeville and its leap to proto-Hollywood, to the feathered fans of Las Vegas, to the gorilla theatre of the 1960's, to the Happenings of today.

We live in such an expressive age of flash-mobs and live improvisation. I think this is important to push our comfort zones, to wake people out of the daze. Yet burlesque exceeds sex appeal by including comedy, music, dance, skits, social commentary, and satire. It's also amazingly self empowering, since it's not limited to any single body type. In burlesque, character is beautiful, presence is beautiful, holding the spotlight and claiming it as your own— is beautiful.

After my accident I moved to Hawaii to heal, and after burning my ten body braces in defiance, I had to relearn my anatomy. There were a lot of things I couldn't do, but at every turn artists would ask me to help them out. Creativity calls for the creative, and I soon found myself helping with productions and fashion shows, costuming at a moment's notice with Devin Mohr, or wiring sculptures with Kui King. One day, Gi-Gi, a choreographer, asked me to be part of her burlesque show. At first I declined, partly because of my injury, and partly because of my age. I had always loved burlesque, but I was never in the position to perform, yet here I was, given a challenge to push myself.

All the women in the show were of different sizes and ages. I did a performance with a woman a few years older than myself, and since she did acro-yoga she lifted me into the air. It was physically taxing, but it felt good to reclaim my vitality and remember what being sexy was like. I was the girl, she was the boi, and it was a fabulous, fun, teasing dance at the Kalani Resort. We got rave reviews, so much so I was soon called in to orchestrate circus troupes and gogo-dancers for local events including Dirty Valentines, Regional Burns, and Pride Parades.

This is how I met Zack and Johnny. At that time, Zack and Johnny had just moved to the island as a couple, though they have since gone their separate ways. During a Dirty-V rave in the jungles of Puna, we threw together a burlesque show. I performed an acro-fire-dance routine with a pair of fire fans and my beautifully androgynous friend Kris, and the boys enlivened us with their imagination. The painting is a frozen moment of macabre fabulousity. Striding out like a pair of conjoined twins, in a single corset made out of an old pair of leather trousers, they pushed and pulled at each other, ripping apart clothes and entrails, with blood trickling down their dying kiss.

At Kona Pride, our troupe wound up performing on a yacht out at sea. It was a booze cruise of delightfully queer people, but waves are no place for go-go boots. I was pretty-well centered, with a parasol dance, but I remember Zack, in his high platforms, bracing himself on the cabin ceiling—which goes to show you can pull off anything with enough style. Later, on Pride Day itself, we danced on a bar-top. My friend, Kasi, who is the same age as me, swaggered up, gave me a devil may-care smile, and said: "The 40 year-olds are holding it down!" At that point I re-wrote how I thought of age. Burlesque dancing can achieve more to give you life again than any long winded seminar ever could. Likewise, I've noticed how truly empowering it is for young people.

Commedia d'Amore

Johnny Rockitt & Zackary Binxx
Oil on Belgian Linen
12 x 48 in.

Bound in a single corset, Johnny Rockitt and Zackary Binxx hit the spotlight in unison. As performance artists they grace clubs throughout LA and the Bay Area, working life with the same imagination as their art.

Having met in Orange County, 2007, they spent two magical days together. Zack was bound for San Francisco, and while they traded parting kisses with locks of each other's hair, it wasn't long before they were sharing a tent in the living room of their first apartment. A year later they cut the trappings of city life and moved to the Big Island of Hawaii and the off-grid raves of Kapoho.

The magic of the island cultivated their love of Kick-ass-Fairy-Unicorn-Mystic performance art. The first incarnation of their double corset was recycled from a pair of trashed leather pants held together with bits of wire, string, treasure and ingenuity. Separating in two complete halves, it reflects how two beautiful and complete individuals can unite into a new whole.

Since then, their Conjoined Act has been featured in numerous venues and performance groups throughout California, including Miss Kitty's Parlor and Wildchild World. Building their club-kid career, the act, the actors and the corset itself has evolved to become even more polished and brilliant with every show.

"I remember Zack and Johnny strutting through Kona in astonishingly high-heels, owning the ground they walked on. You couldn't help but watch. They were the epitome of fierce. Fierce is when you find a place to put your fears, and step beyond them. To be fierce is to own who you truly are, and, more importantly, who you want to be."

—Adare

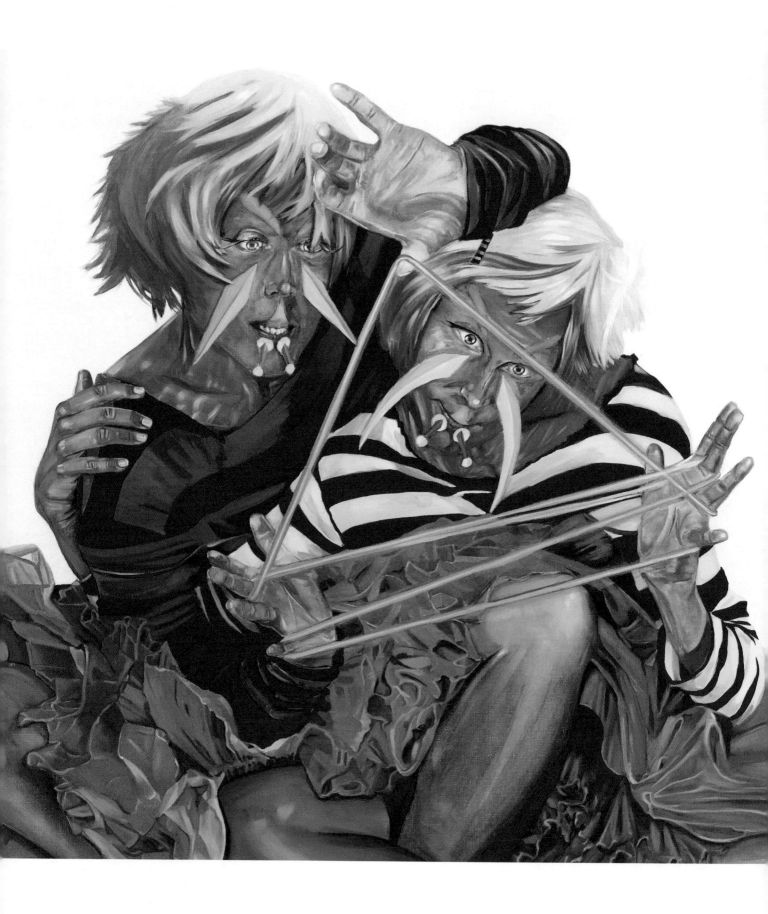

Whimsy

Devin Mohr & Annetta Lucero
Oil on Belgian Linen
36 x 48 in.

Combining haute couture with vibrant performance art, Devin Mohr transforms the human visage into creatures, characters, and dreams both visceral and divine.

With a background in floral art, costume, make-up, and lighting design, some of Devin's creations take root like forest dwelling pixies; others glow in the void like deep sea radiolarians; while others still defy description.

"I'm really weary of the mundane. If I can create a creature who doesn't have a frame of reference for people, that excites me. When it garners the what-the-fuck response, that's always very exciting."

Inspired by film, high fashion, and drag queen theatrics, Devin builds elaborate sets to create a more expansive view of his fantastic universe. His stunning portrait collections *Etherica* (2010), *Xenoflux* (2012), and *Sehnsucht* (2014) not only envision whole new dimensions, but tap into hidden aspects of his models, bringing to light the elaborate unseen.

"Transformation, for me, is like a therapy. I love to do portraits of people who aren't initially so willing to do them. That's a good challenge for me. Then, when I do get them in front of the camera, or when they see themselves for the first time after I've done the makeup, they can view themselves in a way they've never viewed themselves before, which is a great expansive therapy that helps people step out of how they were previously identified."

Teaming up with Annetta Lucero, Devin Mohr provides dynamic concepts for their live performance troupe, Terminal Circus.

Building her career as a three time world champion baton twirler, Annetta Lucero's elegantly dizzying spins won her six US Grand National Championships, the Congressional Cup, and two entries in the Guinness Book of World Records, all while battling and overcoming epilepsy, systemic lupus, a brain cyst, three incomplete vertebrae, and PTSD.

Using her creativity to inspire, Annetta performed with Cirque Du Soleil, while choreographing dynamic acro-gymnastics for Cirque Pacifica, Fern Street Circus, the Palace Theater, and over 50 circuses worldwide. Using her life to inspire, she works tirelessly as a motivational speaker, having delivered a keynote speech for National Domestic Harmony Day, and presented her life story to standing ovations at national psychology conferences.

Laughing at mortality, Annetta founded Terminal Circus as a family show with her partner Noah and her three children.

"We came up with the name because we're both chronic, diagnosed. Noah's a severe diabetic, and I was epileptic and had systemic lupus, and my son Jaidon was terminally ill with metachromatic leukodystrophy and mosaic ringed chromosome 22, and he has since passed away, but our journey has been like everybody's—very terminal—and we think it's humorous and not a tragedy, because people are so prone to denying what our existence is, and that it comes to an end in these human costumes, but it really never comes to an end! So just blatantly stating we are the Terminal Circus made us laugh."

Ever evolving, Terminal Circus shifted into an avant-garde extravaganza, featuring acts both surreal and dazzling at international venues.

wwww.DevinMohr.com

www.AnnettaLucero.com

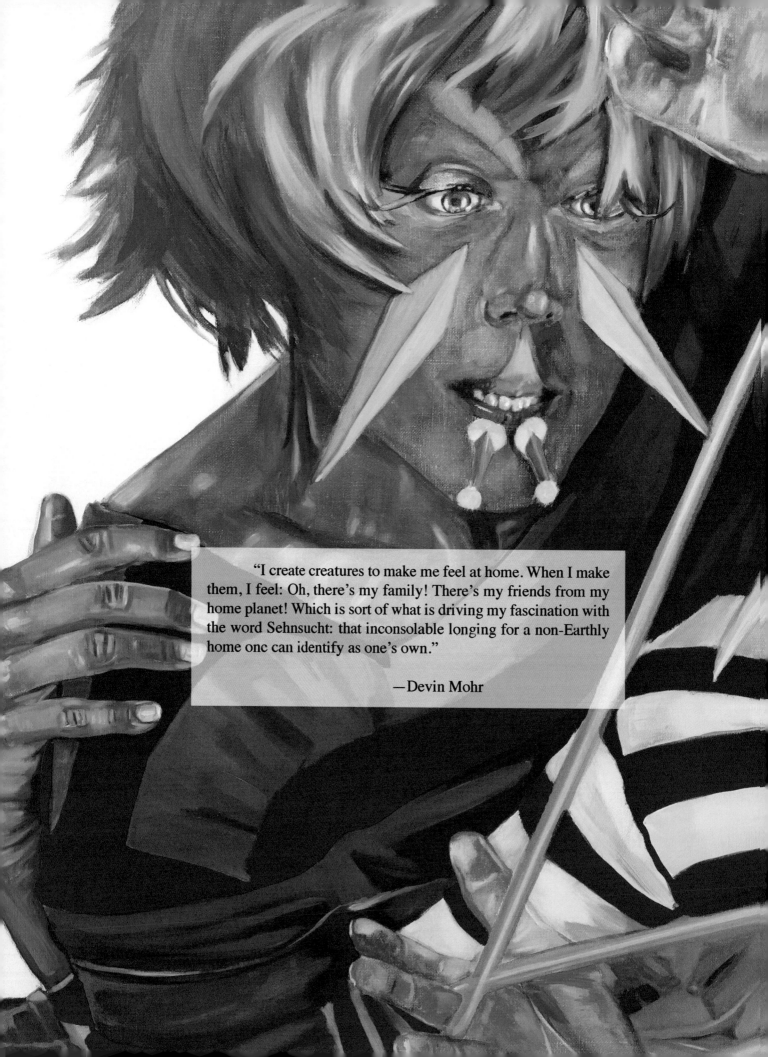

"I create creatures to make me feel at home. When I make them, I feel: Oh, there's my family! There's my friends from my home planet! Which is sort of what is driving my fascination with the word Sehnsucht: that inconsolable longing for a non-Earthly home onc can identify as one's own."

—Devin Mohr

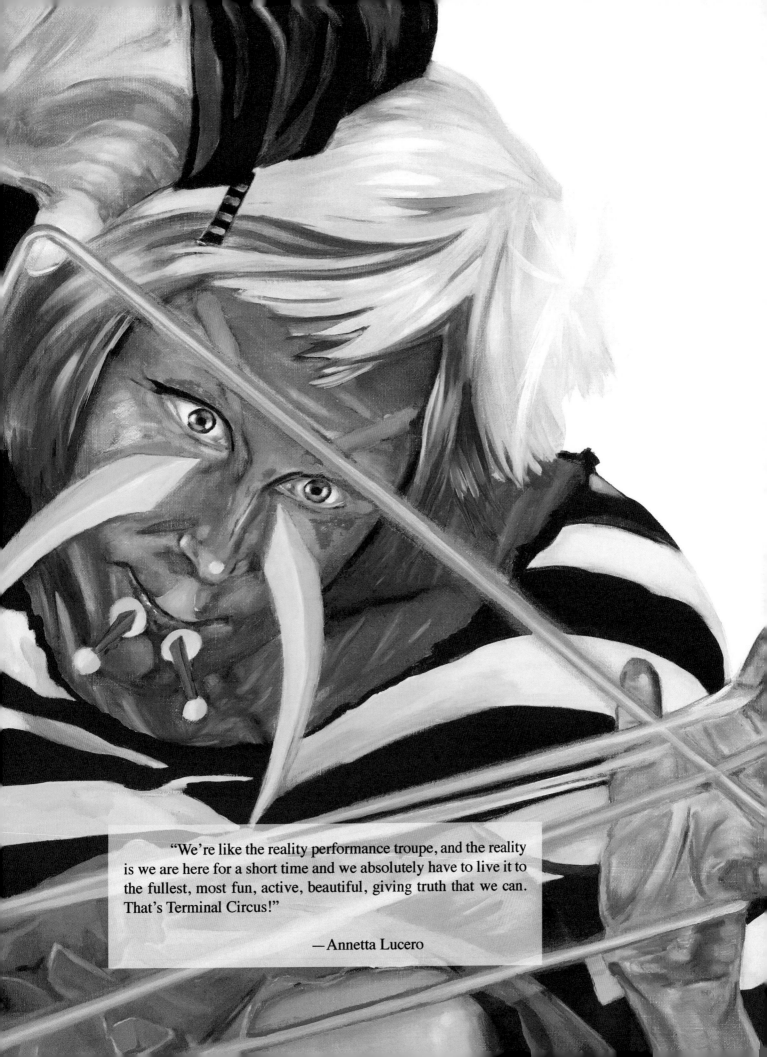

"We're like the reality performance troupe, and the reality is we are here for a short time and we absolutely have to live it to the fullest, most fun, active, beautiful, giving truth that we can. That's Terminal Circus!"

—Annetta Lucero

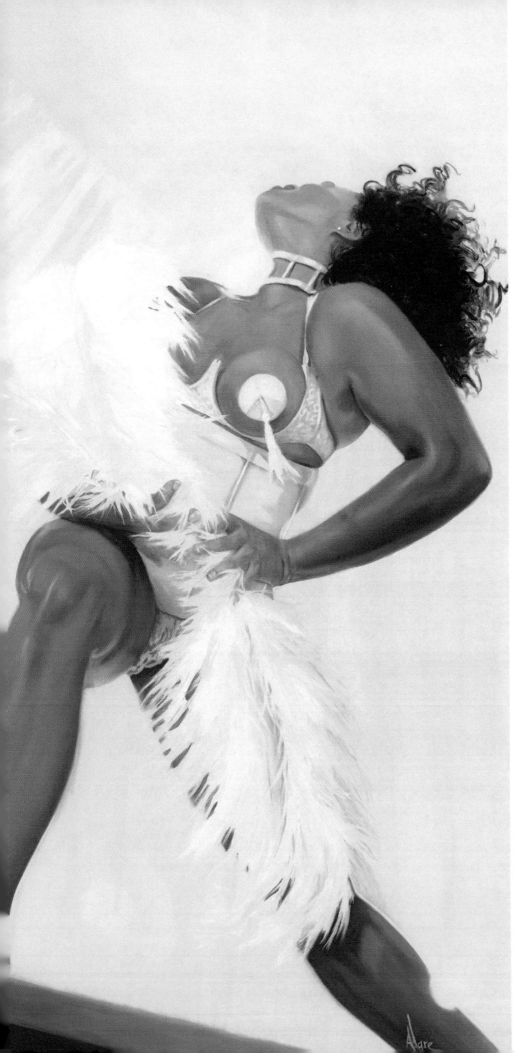

Orbit

Juju Minxxx
Oil on Belgian Linen
24 x 48 in.

Vivacious Juju Minxxx, Hawaii's leather-clad sweet heart, learned how to break-dance, bootie-dance, and own her body at a very young age, usually outside of class while on break from jazz, tap, and basic ballet.

With a mom from Chicago, Illinois, and a dad from Jakarta, Indonesia, Juju grew up working the grave-yard shift at the family's downtown pizzeria until she was old enough to hit the scene.

Spot-lit on stage, Juju followed Burlesque into the fierce and fabulous world of BDSM, becoming a pin-up girl, a stage performer, a vicious Roller Derby skater, and a professional Domme.

"To me, Juju is powerfully, absolutely, and radiantly beautiful. She not only knows her body, she knows the language of her body, and she can convey so much in such a small amount of time. To watch her dance is a giddy experience."

—Adare

"Everyone else was white and skinny, but I was popular, in the token way, being the only Black-Chinese girl. I had a lot of body-conscious issues growing up. My aunt had always encouraged me to be different, to be original. It's kind of boring to be the same, so I adopted that kind of weirdo fashion sort of thing. So I dealt with it through my clothes, wearing my combat boots, floral print skirt, wearing a tie as a belt, a ribbon as a scarf, mixing preppy with punk. I got into thrifting, and I noticed I had a thing for vintage lingerie—the nighties, the teddies, the garter belts. But the lingerie wasn't for sex. I just began stockpiling pretty underwear.

I graduated a year early. I was in junior college, looking for a job, and tired of the family business. My mom suggested the Moroccan restaurants with the belly dancers and I was like: 'Yeah, that would be an awesome job for me!' So I started looking up dancing gigs, which landed me at Burlesque Idol.

That's where I met my friends Mama Sacrifice, Miss Ushiboom the Phoenix of Fuck, and Diana a.k.a Wanda Makeout. I was just old enough to enter the contest, and I won. My stage name, Juju Minxx, came from a mink poncho I found for $18 because the shop didn't know it was real. I worked it into the act. The other girls danced like strippers, but I entered the theater like a sugar-baby just home from a date.

Burlesque helped with my body image because there were so many different sizes and styles of pretty: the gothy girls, the punky girls, the big classic women, all kinds, and they were all very supportive and accepting of the body. And everyone was kinky, and I didn't know it! I had no idea. I thought riding crops were just stage props. I remember, after a 4th of July gig, Daddy Sky, a big Leather patriarch dating one of the dancers, Titty Perkins, showed me his rack of floggers, and it stopped me in my tracks. I gasped. He said: 'You know you can pick one, if you like, and I can try it on you.'

Staring at the wall, five minutes passed. Ten minutes. Fifteen minutes. Then he said: 'You know you can pick a few.' So I did. I picked three. A horse-hair flogger, a paddle, and a crop: a good balance of progression. On their private porch I tried them all.

Titty held me by the hair. By the time Daddy was done, my butt was warm. It was one of the few times I've done impact play and got close to orgasm. And I was really excited. My boyfriend was really into my butt, so I couldn't wait to show him the bruises, but he was mortified. He shamed me. He just didn't understand I could ask for it. And he didn't even want to have sex until the bruises healed. I felt so bad. I bought all kinds of scar cream trying to make it go away.

A few months later, I moved to Hawaii, where I was surrounded by vanilla college kids. I didn't feel connected to them. I felt lonely. There was no burlesque community, no weird people. So Mama Sacrifice recommended the internet, which led me to the secret lady parties in the jungle, and the kink parties, and the leather cons.

On my 20th birthday, I met Rose. She was the tiniest little person ever, who introduced herself as Adare, Fire Muse. She told me about the fire, and the burlesque shows she put on, so I got naked and she played bongos on my butt with flaming torches with a line of naked girls.

After that I started getting involved in Leather & Leis; Petting Zoo Parties; the North American Pony Trainer Leather Title Contest (2013) in Los Angeles, CA; the Paradise Unbound (2013) Variety Show in Seattle, WA; the North American Queens Cup Race (2013/2014); and the International Miss Leather Competition's (2014) Seduction Showcase in San Jose.

The truth is, when I want to do something, it's done. That's the end of it. I wasn't out to liberate myself. I was out to do what I do, and it was just that simple."

—Juju Minxxx

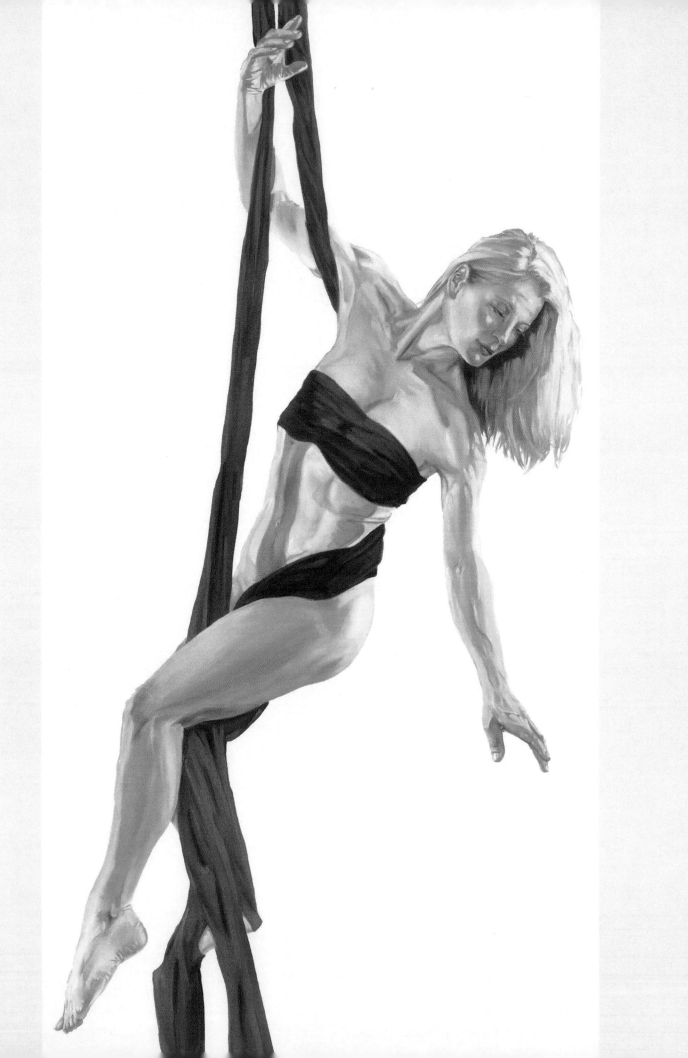

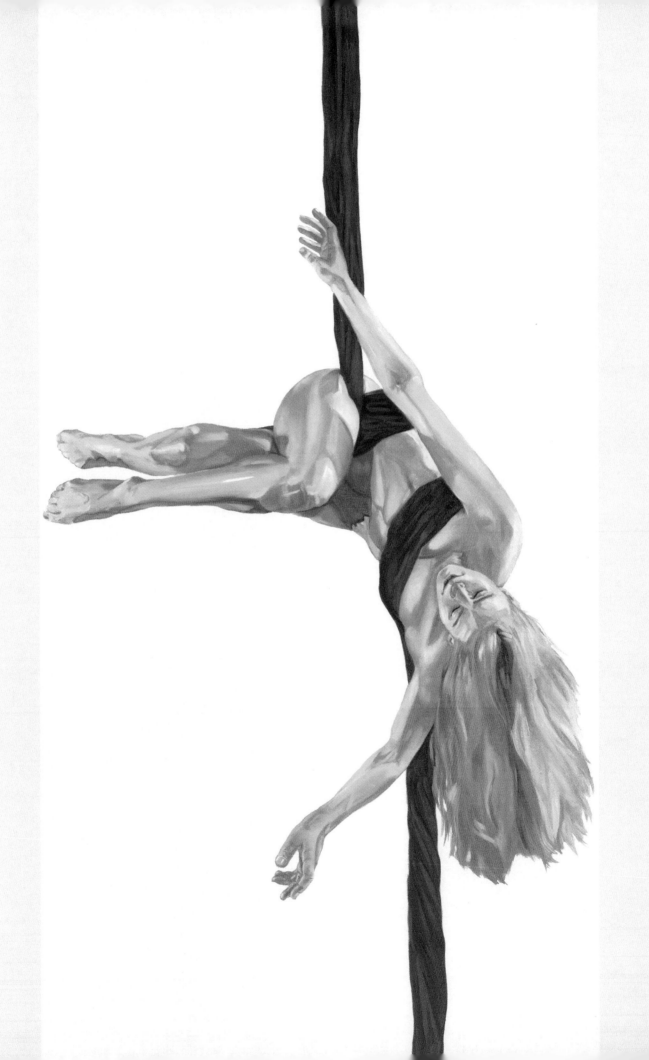

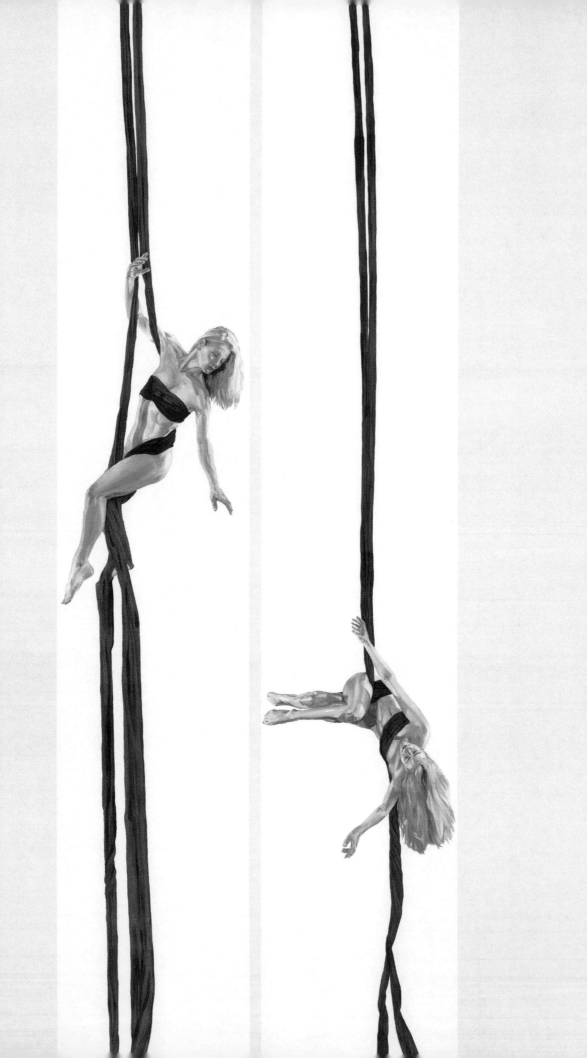

Reach

Dreya Weber
Oil on Belgian Linen
12 x 48 in.

Born in Midland, Michigan, Dreya Weber began performing professionally at 10 years of age, acting in voiceovers and commercials. From there she studied theater, gymnastics and ballet. During college she continued to perform in theatrical productions while competing in gymnastics and diving. After college she left competitive sports behind, her heart taken by flying trapeze. Dreya was director of the flying trapeze program at the International Gymnastic Training Center in Stroudsburg, Pennsylvania. She performed for Circus America, the Royal Hanniford Circus, and the Moscow State Circus.

In 2002, Dreya performed aerial silks at the Winter Olympics in Salt Lake City, drawing attention to her highflying art form. She was soon picked to choreograph and perform the dynamic aerial acts in Cher's *Living Proof Farewell Tour* (2002-2005), and a series of tours with Pink, *Try This* (2004), *I'm Not Dead* (2006), *Funhouse* (2009) and *The Truth About Love* (2013), culminating in Pink's showstopping performances of "Try" and "Glitter in the Air" at the 2014 and 2010 Grammys.

Twirling high above the stage, Dreya also choreographed and performed with such amazing divas as Madonna (*Re-invention*, 2004), Christina Aguilera (*Back to Basics*, 2006), Michael Jackson (*This Is It*, 2009), Britney Spears (*Circus*, 2009), Rihanna (*Last Girl on Earth*, 2010), Leona Lewis (*Labyrinth*, 2010), Kylie Minogue (*Aphrodite*, 2011), Katy Perry (*California Dreams*, 2011), and Taylor Swift (*Speak Now*, 2011). Known for her stamina, Dreya is also a recognizable trainer on Tony Horton's P90X™ workout series (2004, 2011, 2013).

After her film debut in *Everything Relative* (1996) and her role in Lovely and Amazing (2001), Dreya went on to star in Ned Farr's *The Gymnast* (2006), winner of 28 film festival awards, including best feature at *New Fest*, *Frameline*, and *Outfest*. Dreya produced and starred in *A Marine Story* (2010), depicting the hardships endured by women under the Don't Ask, Don't Tell policy. Dreya has been honored with 7 best actress nods for her work in the two films.

From her musical career in the band Common Cents, to singing in aerial stage musicals with Teatro ZinZanni, to guest starring on numerous television shows including ABC's *The Practice*, NBC's *Passions*, and PBS' Masterpiece Theaters *Mountbatten*, Dreya continues to weave her passions and creative determination by connecting with her audience and remaining true to her dreams.

www.DreyaWeber.com

Primal Buddha

Kala Kaiwi

Oil on Belgian Linen

24 x 48 in.

Inspired by indigenous cultural practices, while mixing in his own brand of industrial, stainless steel, Hawaii's Kala Kaiwi is deemed one of the best body piercers in the USA. Holding the Guinness World Record (2015) for largest, non-surgically made flesh tunnels, Kala's stretched earlobes are 4.3 inches in diameter. Instantly recognizable, his body is his art. With over 75% of his body tattooed, 70 body piercings, silicone implants embedded in his brow and his forearm, micro-dermal spikes set into his head, and his nostrils stretched, Kala's presence stands out at body-mod conventions throughout the country.

Developing his skills in Las Vegas, Kala specializes in all forms of body piercing, micro-dermals anchored into the skin, genital beading, scarification, and branding. Kala is also a piercing technician for performance art, suspending individuals off the ground with specialized hooks.

By bringing award winning tattoo artists to Sin City, his Big Island studio in Hilo, he strives to refine body modification as a respectable, licensed art. While many may be taken aback by his appearance, at least initially, Kala is a proud father and a respected member of his community. Going against typical expectations, his art isn't about attention seeking shock value. Instead, Kala views body modification as an intense personal exploration, uncovering what it means to be a human being in the flesh.

"When I started researching about it, and finding out about the traditional aspects of the piercings, the cultural beliefs, the background behind piercings—you know, why people originally started getting piercings, where a lot of the African people started stretching their lips and beautifying themselves by stretching their ears, and stuff like that—I started realizing—wow! This is a whole different world that I never knew about, but I'm really fascinated about, and I want to know more. I want to find out more! So, at that point in time, I said: You know what? The only way I'm going to be able to find out more is if I really do become a body piercer and work in this shop."

—Kala Kaiwi

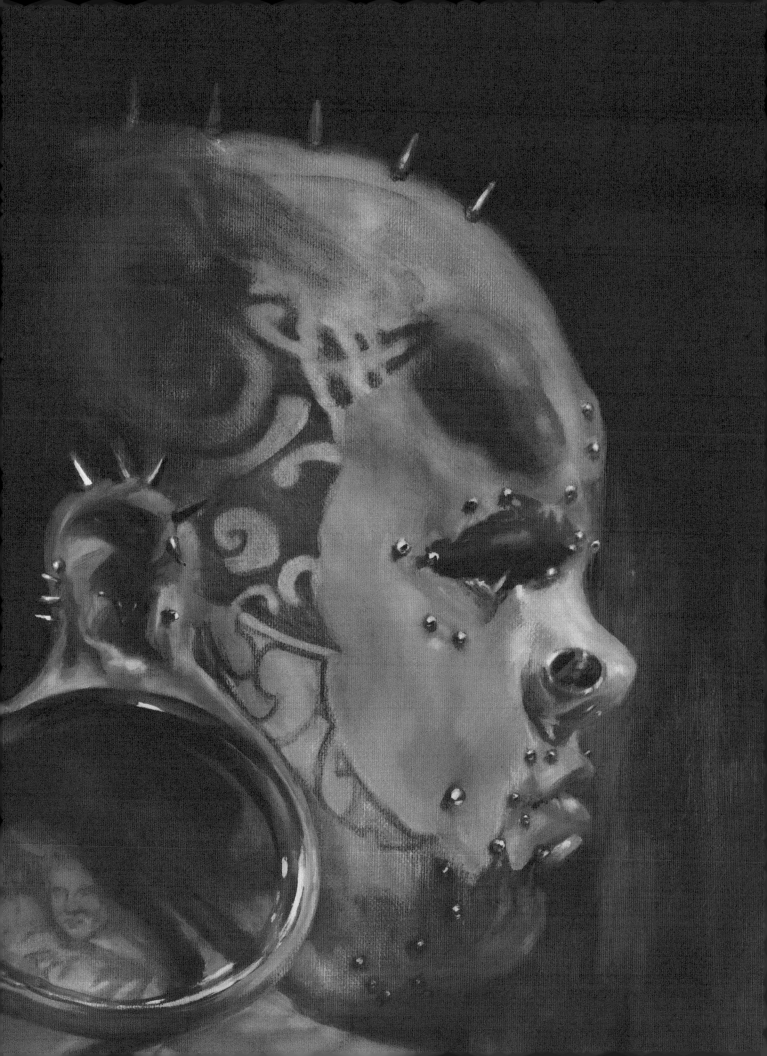

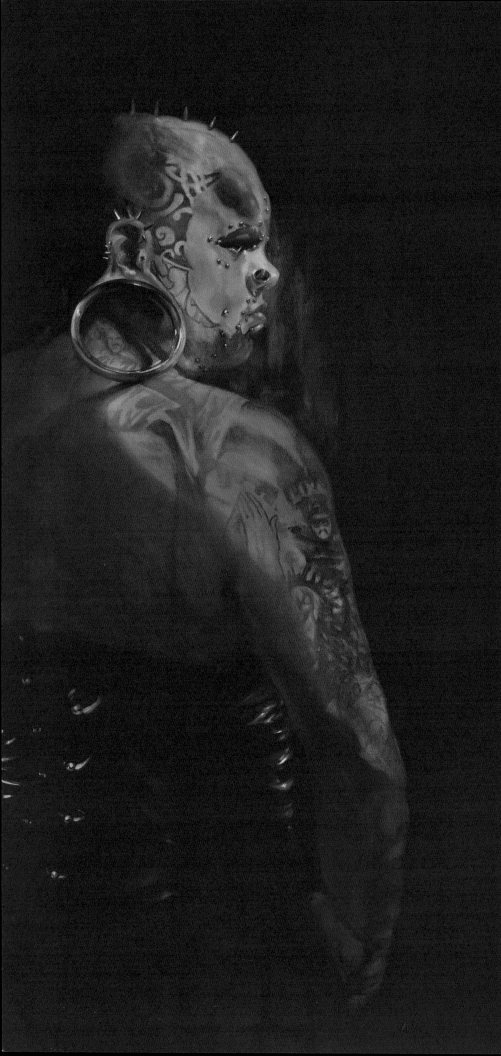

While envisioning all the culturally diverse forms of corsetry, I remember wishing someone had a corset piercing. Next thing I know, Stembot, my model, was on the table in Sin City—Kala Kaiwi's professional studio—lancing 14 hoops into her back. This is a bohemian act: not impulsive, but completely unafraid. Blown away by her commitment and her bravery, I watched in awe as her toes curled and she breathed out the pain. I believe that when people step out of their comfort zone, they form their strongest memories, and when people say: "I would never do this," or: "This isn't like me," they're actually forming their strongest character.

That was the first time I met Kala. At that time, he had just implanted a row of metal spikes into his head, and his stretched ear lobes were competing for the largest in North America.

As with all artists, body-mod experts compare with each other to push the boundaries of their skill, but it's not a competition. Body modification is an exploration of self, and Kala has an amazing curiosity.

Like everything, there are always reckless beginners, but there's a level of true professionalism in body modification that I really admire. On one side, the tie to culture through Maori facial tattoos or aboriginal lip-discs reminds us where we came from. On the other side, we're talking about scarification—surgical art—and there's nothing impulsive about it.

When I began his portrait, I had him pierce my ears with four spikes along the top cartiledge so I could feel them heal as I mixed my palette.

Because I work in layers, I remember the strange joy of painting Kala's skin first, and seeing him without any tattoos or piercings at all. Then, one by one, I painted them in, to see the man he is today. I love his portrait, *Primal Buddha*, because there's a nobility there: he's a good father, and a well loved member of his community, taking pride in what he does.

The art of tattoos and body-modification is ancient, tying into ritualistic ceremonies throughout Asia and the Pacific Islands. Likewise, piercings are a natural part of many indigenous cultures—African, Aboriginal, and Native American, even developing into intense spiritual rituals in India and the Middle East. Some are rights of passage; some, connections to the spirit world; some, marks of conquest.

Culturally, some people use tattoos and piercings to test endurance by overcoming, embracing, or transcending pain. In either case, Western cultures often idealize a kind of chaste, physical purity—a kind of pale, soft skinned virginity. Even in secular groups, body-mods are seen as something only damaged people do to themselves, and that's simply not true.

When the European sailors encountered tatau body-art, tattoos became synonymous with the adventurous high-seas lifestyle. Not long after came the electric tattoo gun, making tattoos more affordable. Yet for a long time tattooed people were the subject of circus side shows. The newly formed health boards shut down the majority of tattoo and piercing shops during WWII in an attempt to stop the spread of disease. Consequently, the mainstream public viewed tattoos as a dirty, criminal pastime.

There are many amazing tattoo artists and body-mod experts, both in history and alive today, who have helped to validate their art, yet one of the most notable was Fakir Mustafar, the father of the New Primitivist movement. With tattoos, daggers lancing his pectoral muscles, and a corseted 19 inch waist, he observed how the West's sheltered lifestyle robbed people not only of experience, but of the comprehension of their own bodies. Since then, the counterculture youth movements, the biker gangs, and the punk rockers have developed hundreds of artistic tattoo styles while exploring the limits of body piercing and the very definition of beauty.

One of my favorite compliments was when a young woman told me *Acceptance* reminded her of John Singer Sargent's *Madame X*. The static pose and the quiet grace are very nostalgic, but she was referring to the ribbons pierced into her skin. She told me that Sargent's *Madame X* was scandalous because the fallen strap of her dress insinuated a proud sexuality, yet in a modern era where women are continuously sexualized, the image of scandalous beauty carries with it a very real, and very physical pain.

Fallen about Stembot's hips is a leather trench-coat. Green paint lines her face, and eighteen hoops pierce her skin. Yet more people are offended by the near, unnoticeable drop of blood. They want her to be dangerous and perfect, but that little red line makes her human. It makes her real.

I soon found myself admiring the world of body-modification, especially when I moved in with a young tattooist named Robert. He is one of the few people in my life I think of as a brother. I adore him, as both an artist and a work of art in his own right. Robert's tattoo style draws from a diverse array of art, his childhood in Albuquerque, New Mexico, evident in his candy-skulls. Unlike many tattooists, he's also a dedicated painter, granting him an amazing knowledge of shading, depth, and form. Exploring the surreal beauty of scarification, subdermal piercings, and flesh suspensions, he learned to tattoo on his own body, emulating techniques before developing his own.

His portrait, *Ardens*, Latin for *Fiery*, was accepted into the Maui Arts and Cultural Center's prestigious Schaefer Portrait Challenge, 2012. A tri-annual exhibit of Hawaii's finest portrait artists, the challenge celebrates influential members of Hawaii's community. Yet instead of submitting an elder, or a grandmother, or a wizened Kahuna, I presented a tattooed young man, with a pierced forehead, thriving at the heart of his scene.

"Growing up in suburban Virginia with fairly conservative parents, I was not exposed to many 'taboo' things. I didn't even hear a 'curse word' until the 6th grade. When I was 8, I met my father's cousin Vicky, a merchant marine decorated with tattoos. I remember being fascinated by the colors and designs and the idea that people could permanently wear art on their skin. I was hooked. I would sneak onto my parents' computer and look up images of people with tattoos and piercings, scarification and branding. I became so drawn to the idea of the body as canvas: that the body we are born into is not the one that we are confined to, but that you could change it and shape it to be whatever you want it to be.

When I was 16, I found a tattoo shop on the outskirts of town that didn't ID people for piercings. I got my navel pierced first, and within the next month I got my nipples pierced and my first corset piercing.

My foray into body art was brought to an abrupt end when the school nurse informed my mother of the rumors going around about my piercings. My mother and I would continue to have a strained relationship for years after this incident revolving around my modifications. I still remember the day, many years later, when she told me: 'You are who you are, and I love you for that.' I broke down in tears because she finally realized that my modifications did not change who I am at my core.

In college, I used my education to learn more about the body modification community and to network with practitioners and collectors. This is when I finally started to add tattoos to my collection and did my first suspension. I also started modeling during this time. I started as a model for two friends' clothing companies and quickly moved to doing nude work.

Doing nude modeling was so freeing and liberating, and was the perfect way to show off my adornments. Through my love for both modeling and body modification I was able to follow my passions across the US, meeting friends, lovers, and people who have changed my life in so many ways.

While I continue to add to my collection of modifications, I have become rooted back in Virginia. I have replaced my corset with a full back tattoo reminding me of my inspired travels (especially my time spent in Hawaii).

I have balanced my professional career with also helping to raise a family and working as a freelance model and sex shop worker. I continue to challenge the thought that changing the way one looks on the outside has any relation to one's character or abilities.

I am lucky to work for and thrive in a very large company that holds the same ideas about the individuals that work there. I am a perfectionist, a lover, an artist, an exhibitionist, a libertarian, an overachiever, a tattoo collector, and I am accepted."

—Stembot

Acceptance

Stembot
Oil on Belgian Linen
12 x 48 in.

As a fetish model, Stembot followed the camera from her home in Virginia to the farthest points of America. Working with professional photographers and up-and-coming artists, she models periodically for alternative clothing companies and private couturiers.

A libertarian with a degree in sociology, Stembot embodies the 21st century woman, poising her professional career with her artistic license, creative expression, and sensual lifestyle.

"As an alternative model, Stembot's classical beauty carries a modern day edge. Embracing new ideas, she's very open to trying spontaneous, creative visions. Unlike many models, who remain as blank as living mannequins, she is very much herself. Even in such a calm painting, her essence remains intact."

—Adare

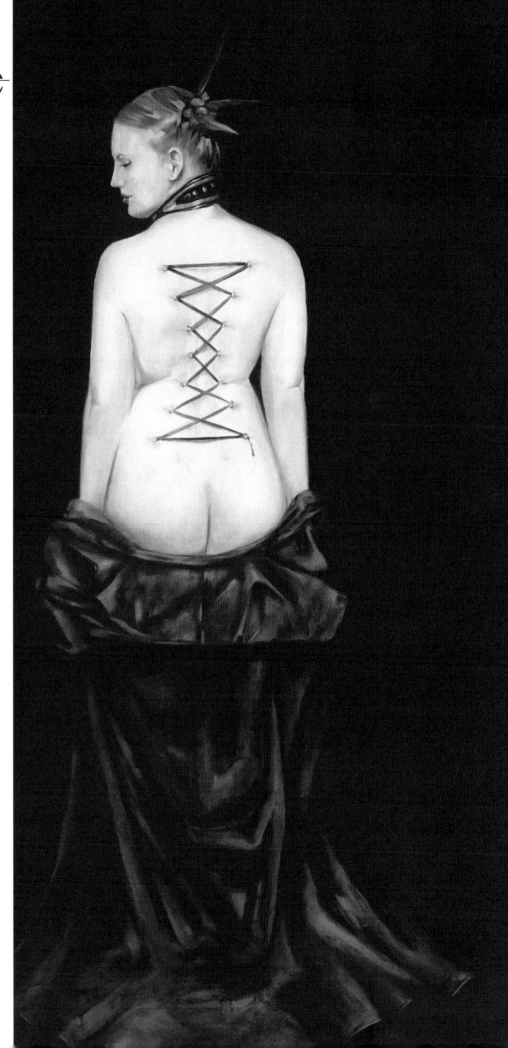

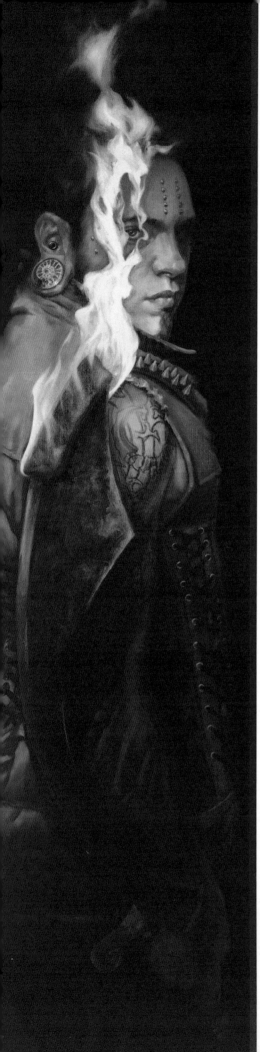

Ardens

Robert Bennett
Oil & Silver Leaf on Belgian Linen
12 x 48 in.

"My Grandma was definitely an inspiration to my art. She was always super supportive. She would always hang onto my drawings. She always said she would sell them one day and make millions. She was a professional doll maker for over 30 years. She'd always have a class with a seminar going on, and I'd be the kid running in, checking on how they would paint the eyebrows on.

First tattoo I did as a professional artist was a little filigree heart on a girl's ankle. It stressed me out. I was sweating bullets, but she loved it and that drove me to try better, so I kept trying and trying. I'm still trying: an ever evolving daily extravaganza. Roundabout that time I got my forehead pierced. While hanging out at the shop I asked Kala if it was physically possible. He had no idea but thought they'd get rejected, so I told him: 'Let's do it, let's try it and see if it works.' Later, the guy who invented surface piercings, Steve Hayworth, was in shock and awe that we were not only able to do it physically, but that they'd stayed in all these years. They're still in the same place. As far as we know I'm the only person still walking around with them.

After I got my forehead done, my idea was to do one of every modification that there was, tattoos, piercings, implants, scarification, the whole nine yards. But after getting branded a couple of times, and after the scarification, I've kind of changed my outlook. Maybe I'm only going to get a couple of them, not all of them.

I did start doing suspensions with my friend Steve. I'd seen it before and I thought it was super fascinating. Why would anybody hang from hooks from a tree and dangle around? I never thought that would be ever appealing until I asked to try it once, just to say that I'd done it. So we got set up, but I didn't think it would happen.

Weather change: rain, lightning, huge tree. Scared the crap out of me. The pain during the actual hooking procedure was the worst part as far as I was concerned, then your body kicks into high gear and you don't really feel it anymore. But when they pulled me up to the actual tree? Rain, thunder, light show? It was one of the greatest experiences that I'd had at that point. I became addicted to it after a while. I've done a lot, but the last one I did was at my friend's funeral. He used to do suspensions as well, and when he died we suspended off a tree in his backyard. Ever since then I haven't been able to bring myself to do it. I don't think it's dead in my life. I just haven't had the drive for it. I'd rather suspend other people and let them experience something new."

—Robert Bennett

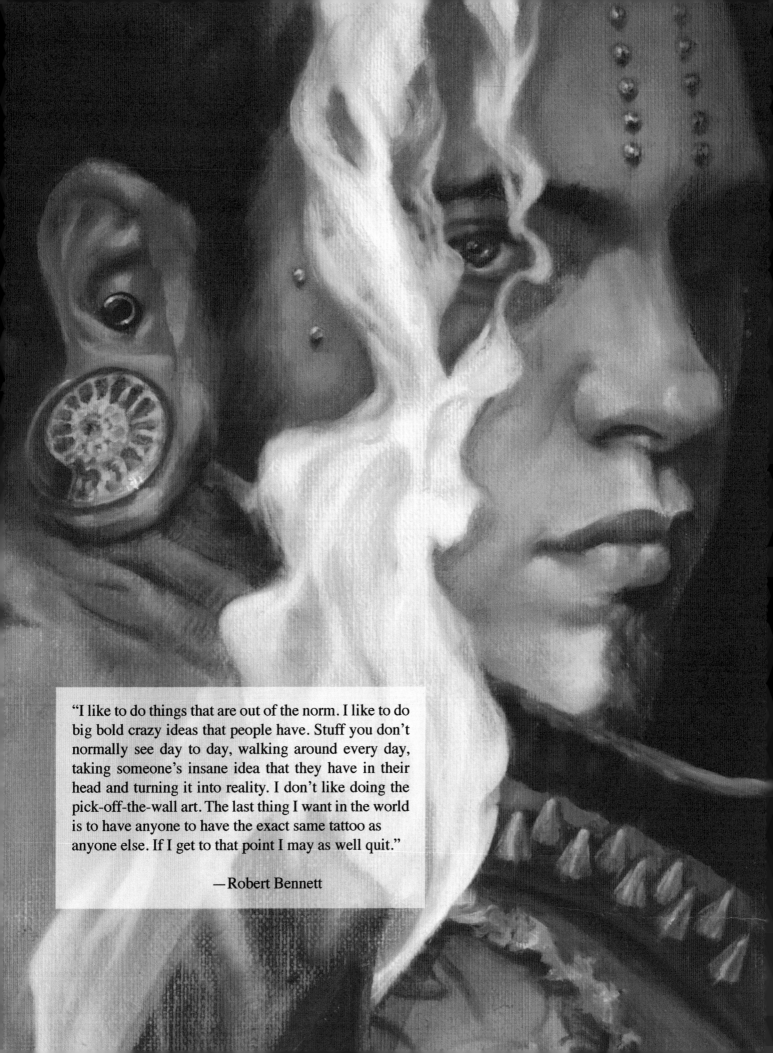

"I like to do things that are out of the norm. I like to do big bold crazy ideas that people have. Stuff you don't normally see day to day, walking around every day, taking someone's insane idea that they have in their head and turning it into reality. I don't like doing the pick-off-the-wall art. The last thing I want in the world is to have anyone to have the exact same tattoo as anyone else. If I get to that point I may as well quit."

—Robert Bennett

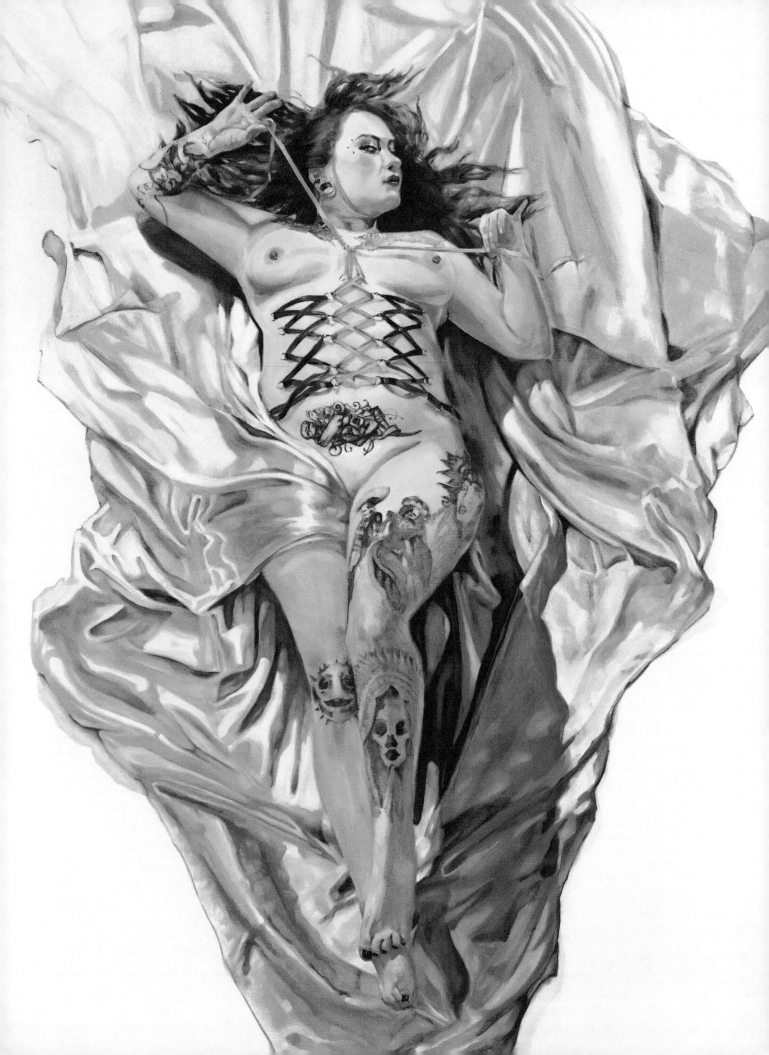

Venus Unbound

Jesi Collins
Oil on Belgian Linen
36 x 48 in.

Born with congenital hip dysplasia in Port Angeles, WA, Jesi spent most of her childhood in body casts. When they finally cut them off, she laughed: "Look, Mom, I have knees!" Growing up in a 12 volt, off-grid house in Hawaii, Jesi spent a lot of time drawing, or else swimming in the old, redwood pickle barrel rain catchment tank whenever her parents weren't looking.

"In 4th grade, I stole a tattoo magazine out of my brother's room, the Sept. '94 edition of *Skin & Ink*. Until then I hadn't ever thought about what I wanted to be when I grew up, but secretly I wanted to be the lady in the article. I didn't want to grow up to be like her. I wanted to be her, because I thought she was a tattoo artist. Found out her husband was the artist and she was just talking about it. I think I decided then that being a tattooist would be a really cool job."

After getting her first back tattoo at 16, Jesi graduated early and back-packed around the mainland. Returning to Hawaii, she soon found herself pregnant. In need of money, she went down to the local tattoo shop and wrote her phone number on the bathroom wall: "When you need help, call me!"

"When they called me back to clean the shop, I never left. I didn't give them a choice. Learned how to make needles, scrub tubes, scrub floors, a lot of floor scrubbing, a lot of needle making. Finally, one day, I tattooed my ring finger: *No Love Lost*. You can't lose something that's not a material object. Love's just a state of mind. Nancy, the owner of the shop, let me tattoo my friends after that, and I began fixing their ugly homemade tattoos."

Raising her daughter in an old bread truck, Jesi made magic out of impossible situations. Irregular hours and flexible schedules let her work around her daughter's school needs, while saving tattoo tips afforded them both a better future. With practice came skill and notoriety, building Jesi a huge client list of friends, family, and tattoo fans lining up for her work.

"Raising a child is probably the most beautifully morbid thing you can do. I don't know how many people can actually shit on you that many times in your life and you still mean it when you say you love them. Besides, I don't think it's every day you get blessed with a kid who's good right off the bat. From such a young age she was into the wellbeing of other people, and was very attentive to that, and that makes me feel very accomplished."

—Jesi Collins

"Jesi and I bonded over our pain with laughter. She was born missing a huge piece of her hip and spent a lot of her Hawaiian childhood stuck in a cast. I'd say she's a survivor, but she's more than that. She's an enjoyer. On her right leg is a blow-fish which puffs up when she bends her knee. In the back of her hand is a starfish implant, and she has a magnet embedded in her finger to perform magic tricks for her daughter.

I remember on her birthday we went to the cliffs to see her suspended from a tree. She had meat-hooks in her back and headphones in her ears, and she flew out over the waves — grinning like a pierced tinker-bell! As a tattoo artist on a truly unconventional path, I've watched her grow into an amazing human being. From having to live in a bread truck to becoming one of the Big Island's most notable tattooists, she continues to inspire me. Even for this portrait she was pierced 36 times, and when we cinched the ribbon — pulling all the hoops in her skin — she chuckled."

— Adare

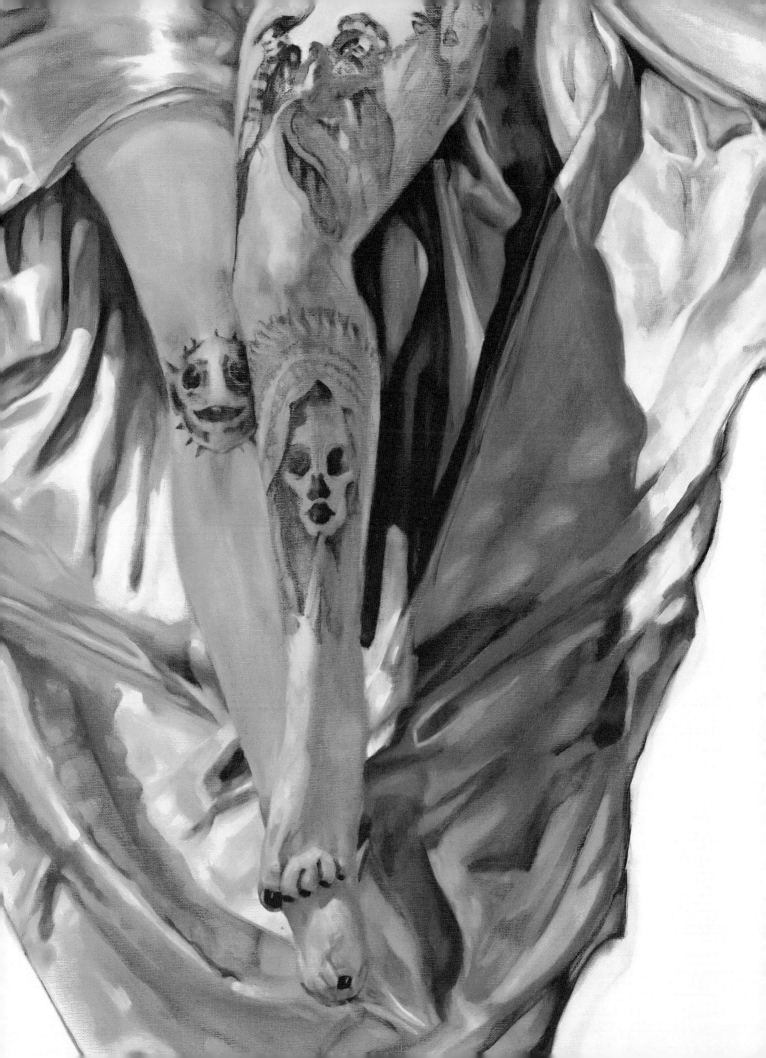

Raw Canvas

Rose Adare
Oil on Belgian Linen
24 x 48 in.

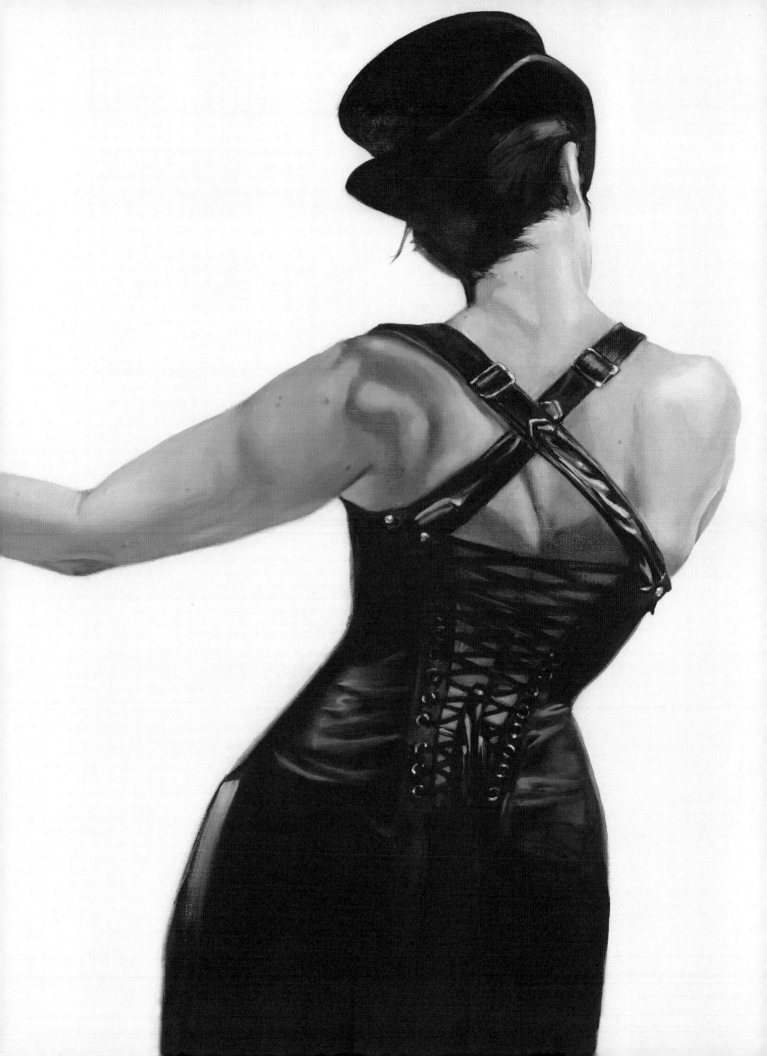

Rose Adare

Life is mostly mundane. I live in a beautiful garden, painting in the company of people I love, sharing stories with those I care most about.

Obviously, Restraint & Revolution is all about inspiring life stories and inspiring people, yet all of the biographies, including my own, are merely a series of chiaroscuro shadows and highlights. There's always more than one way to tell a story. Yet when you see one person not only survive but thrive, it gives you hope to do so as well. With that in mind I wanted to share some of the Restraints of my life, to emphasize the importance of personal Revolution.

I first began oil painting when I was seven. My teacher, Mrs. Blanchard, was a sweet older woman who used to paint flowers on porcelain teacups. My first painting ever was a tomato. The second was a roll of toilet paper. They're both pretty damn good. I always bumped into things throughout my childhood. I had an amblyopia (lazy eye), making the world two dimensional. I had three corrective surgeries, the last when I was nine. The anesthetic didn't knock me out so I was awake, paralyzed for the whole procedure, staring down a scalpel puckering the film of my eye. I spent two months blind, which is how I came to understand color. I had a wooden pull soldier toy, all red and blue, and I could feel its colors, even if I couldn't see them. They vibrated. I quickly learned to feel objects before bumping into them.

Red was wider and lower to the ground, all boom-boom warm. Yellow was more up-and-down, zoom zoom zoom—definitely the fastest!

And blue was cooler—slower and lower than red, but rounded, softer.

Often, when I woke up, I didn't know if I was still dreaming or awake, which is probably why I still have amazingly vibrant lucid dreams. It wouldn't be my last eye surgery, or the last time I spent a few months blind. I was the hyperactive kid with eye patches, braces, and a speech impediment, dressed in black and purple with my big black boots. Early on, I figured that you had to be yourself, and that the true people will find you. So I didn't just march to a different drummer: I ran, literally. One of my favorite pastimes was to run around the school until someone caught me, after which I'd sit on top of my desk in protest. That was my first experience with Revolution.

I remember when a kid accidentally cut my forehead on the playground. Blood gushing, I ran around the school until my teacher caught me, my blood spattering down his all-white front. When the hospital told me I needed stitches, I punched the doc square on the jaw. I was so terrified of another eye surgery that they shoved me in a medical straight jacket. There's a stiff wooden board that runs down the spine so you can't move, and it doesn't have any sleeves. It just wraps around you with a thick linen cloth and a neck collar that clamps your throat. That was my first experience with Restraint.

I was the kind of kid who built her own photography dark room when she was fourteen. The kind who would sneak out of the house to ride her friend's horses. The kind who pretended to be

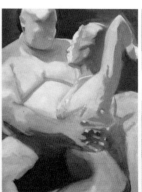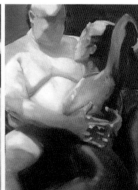

a carefree washer woman at the local Renaissance Fair. I was also the kind of kid who wouldn't let teachers correct her art. He kept trying to paint on my paintings. It's how he taught, and it pissed me off. It wouldn't be mine if he touched it. I wouldn't learn anything. So many teachers in life try to take away your authenticity by telling you their expression is more valid than yours. Who cares if I don't draw like them? I draw like me. As a child this was just a rebellious sentiment, but when I went on a school tour of Europe I learned that a lot of the old masters thought the same way. Sure, we were intoxicated teens, graffitiing martini glasses on the side of our bus, and sure, I wound up ridiculously hung-over trying to stare at the ceiling of the Sistine chapel, but I learned something crucial. The center of the Vatican—the temple of God—as it surprised a dizzy thirteen year old, is covered in naked men. Michelangelo went to Rome and painted scenes from the Bible, but he did it his way—his sexy Herculean way. Later, they hired a guy to paint pants on the Last Judgment, but the ceiling remains, each corner framed in by buff giants.

I was, for the most part, a good kid, naive in a lot of ways, which dropped me into a lot of situations. The second time I had sex, I got pregnant. I went to my cousin's home in Oregon, where I attended the Sunset high school for pregnant teenage girls, a pseudo daycare in the basement of an elementary school. All the girls used to squirt milk at each other. Since they all had multiple kids, they came down on me for deciding to give up my child. I think that's when I entered my goth stage. I became introspective, wore lots of black, and kept my head down. My choices became iron-clad.

I got pregnant between All Hallow's Eve and All Saints Day. We were at a Hollywood party—a tearing down the house party—so everyone came to destroy it with chainsaws and sledgehammers. There were a bunch of makeup artists there, so the costumes were insane, with the classic briefcase full of drugs. Of course, I was the only sober bookworm at said party. I had dressed up as a cat in a one-piece spandex body-suit, with cat ears and crutches (crutches after trying to run away from my violently abusive brother). I later threw those crutches onto a freeway.

The next day, I sat on the bed and knew that I was pregnant. Within a few days, I knew exactly what I was going to do. The plan was intuitively laid out. I found a lovely couple in Oregon, Mark and Cindy. We agreed to an open adoption where I would get a letter and a picture once a year, and when he turned 18, if not before, he would get a letter from me.

Gabe decided to be late, and the doctors chose to induce labor. I was in pretty good spirits and making jokes the whole time, which was a mistake. Later, when I asked why they didn't give me any painkillers they said: "You asked so politely, you obviously didn't need them."

I could have killed that nurse.

But something happened in the midst of it all, which I might not have seen were I numbed out. When I was delivering—pushing and screaming—I saw a flash, like the inside of my womb. I saw the top of his head and his feet, and what looked like a tunnel with curved blue lightning. And the blue lightning was making flashes of images—of a young, shoeless boy in rough clothing facing a man on a horse with a long thin blade. The boy was bent over, holding his stomach, and

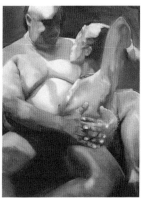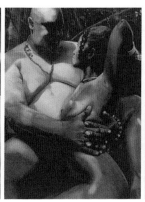

he started to scream. At that moment Gabe started screaming, and he was born.

He was born on a Friday, another odd blessing. Lawyers don't work on weekends, so I got to spend three days with him, in a hospital room set up like a mini-home. The first day he looked like a ponderous old man fretting to remember. It wasn't until sunrise that his fretting left and he transformed into a baby, newborn and impressionable. He would grab my finger and suck it.

Monday brought Cindy. We talked, and I showed her Gabe. At that moment I should have handed him over, but it didn't even occur to me to let go until the nurse came in. Because I had committed, I gave her the baby. It was the first time I had ever felt like having a knife through my chest. I couldn't breathe. And then I went outside, and waited for my cousins to pick me up, where I learned never to smoke cigarettes.

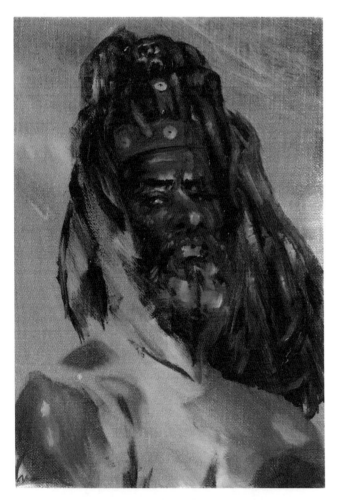

Fire In Steady Hands Study
Oil and Gold Leaf on Belgian Linen
11 x 14 in.

As I sat outside, feeling depressed for myself, an old woman rested beside me, mumbling. I asked if she was okay. Invisible knife in my chest, I asked if she was okay. She half coherently rambled about how the doctors had told her husband to quit. He hadn't listened to them. He hadn't listened to anybody, and now he was dead, and what was she going to do with three kids? She was very angry, and talked about those damn cigarettes. I always go back to that moment, where I learned not to wallow while others are hurting as well.

I received not one, but three letters a year, and was able to meet Gabe when he was 13 along with his adoptive brother Sam, the yang to Gabe's yin. I visited them twice a year until they were 18, and have always been grateful for being invited into their beautiful family.

I left Oregon to go to Foothill Community College where I took acting classes, more for fun than anything else. At that time, I was living out of my truck trying to be independent. I'd put down a carpet kit in the back and had taken to parking in residential areas, since they were generally safer, or at the college until the dean told me I would get kicked out for doing that. I remember this one specific night in the truck, trying to open a can of corn with a blunt knife because I was that hungry. My friends would share their food with me. In a way, it was an important experience. Hunger put a lot of things into perspective for me. I know what it's like not to have food. Everything else is just a small annoyance after that.

Sacramento: I married, I divorced, and I was happy about that. Alcoholic womanizing Cajun liar—the kind that sliced his own chest to show how much he loved me. Driving, with two friends in the back, he screamed: "If I have to die, then I'm taking you with me!" So, at 80 mph on the freeway, I opened the door and told him I would jump—one, so he wouldn't have the satisfaction of killing me, and two, because whether I jumped or not, he would pull over and our friends wouldn't die, too. I was counting on his selfishness, his need to not die alone. When he pulled over, one of the guys in back punched him. After that, I gleefully escaped to Europe.

Europe showed me everything I did not want in my life. Since then, I've had much better

trips, but at that time I wanted to experience a real English winter. Staying at a British youth hostel, playing cards with international travelers, I soon rented a place from a pervy old man. Sitting on my bed, flipping through female porn, he would ask me all sorts of questions about being a lesbian. (Like I knew at the time!)

Applying for an au-pair position, taking care of children of a magistrate, I was invited to his estate for the weekend. Naturally, I didn't think anything of it, so I took the train to the countryside. He picked me up in a red convertible and drove me to his manor, which was covered in beautiful black-and-white photos of naked women. No kids. No pictures of kids. No nothing. When I asked where the kids were, he looked at me, cocked his head, and burbled: "Ga-ga-goo."

Stuck in the country, I spent the entire time listening to a friend of his discuss the finer points of vulgarity—making me more than a little concerned for my safety. After dinner, I attempted to sleep on the couch, though he was being handsy—at which point the Princess walked in.

I had to pause.

Her name was Christine. She was a Lady Di look-alike just returning from a photo-shoot in Switzerland. Later, she would work as extra in the film of Lady Diana's life. She saw the situation, made the Magistrate a sleep tonic, put him to bed, came down, apologized profusely for his behavior, and said that she would drive me back in the morning—and that I would be safe while I was there. I totally fell for her.

Sadly, it was the magistrate who took me back in the morning, rambling about how much Christine liked me, and I confessed that I really liked her, too. She and I started talking on the phone a lot. Deciding to go out, we hit an underground, private club in London. A limo picked me up, but she wasn't alone. There was a guy in back with her, and she was in a wig (as part of her contract as a look-alike she couldn't be seen in bars in case of tabloid rumor).

The club was crazy, machismo bullshit. In the bathroom, she and I started talking. I mentioned my crazy living space with my lewd landlord, at which point she grabbed me, declaring: "You can come live with me." My heart fluttered.

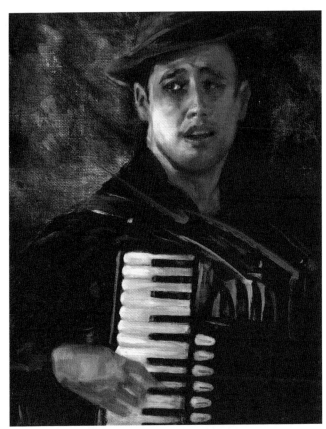

The Eleventh Hour Study
Oil and Gold Leaf on Belgian Linen
11 x 14 in.

"And when I'm out for model shoots, you can take care of my clients." I didn't register what that last part meant until later.

At the end of the night she was blitz drunk and making out with the guy from the limo. I didn't understand. I thought we were going out. It turned out he was a producer of an S&M magazine, and while he was showing us around his house, he offered me £10,000 for two weeks of subservience, because I looked really young. Apparently, a 4'11", twenty-something with childish pigtails was the golden ticket. They asked me to join them in the bedroom and I declined, stating I was tired. Christine was pissed off at me for "not playing the game," and I lost contact with her after that.

Tired of fucked-up situations, I left my creepy landlord to live with a pair of old ladies who denied any connection with the world past 1950. Their advert in the paper read: "Are you frustrated with society? Do you feel a connection with the old world?" Visiting their gorgeous, antiquated manor house in Snarsbrook, they asked if

I had ever channeled. I said no. I'd acted before, but never channeled. Deciding to try an experiment, they began a kind of loose hypnosis. Asking my favorite time period—I said the 1900's—they popped a record on the gramophone. It was really easy to fall into being somebody else, since as an actor my imagination often went there. A girl by the name of Anna "surfaced," but I wouldn't have called it that. I played the game because I really wanted a better place to stay, I believed in past lives, I loved corsets, and it seemed safe. They provided lost souls a place to stay in exchange for work. They told me my cooking was horrendous. British people told me my cooking was horrendous. I state, for the record: I should not cook.

One of the girls staying there had scars up and down her wrists from a previous suicide attempt. Together, we stayed in a little, economy sized apartment. It was easy to play along, and for four months I lived there, becoming characters like flapper American Lulah from the 1920's, and prim English Anna from the 1900's, while simultaneously earning my massage license from a funny old Australian Mormon. Everyone's plan at the massage school was to give two-person massages with happy endings. It was a big money maker, but I didn't want to play that game.

The old ladies would host parties, inviting politicians and archbishops, and we would entertain them by switching characters. It was really enchanting, in a way, to be gregarious one moment and a wallflower the next, manifesting lavish cocktail parties or dainty high-tea.

Unfortunately, there was a problem: the pair made money through caning, and they wanted to create vintage photos. Naturally, since I looked the youngest, they wanted me for the role, so my one shelter wasn't without its antique fetishism.

Deciding to leave, I went to a backwater Episcopalian church, where I watched the people twitch and convulse. Tired of sexual advances, I asked the deacon if I could join, but he said without a lifetime commitment, it wasn't for me. So, with no money in my pocket, I went to Scotland. I slept in a graveyard and was attacked by slugs; I slept on a park bench, and woke up to harassment; I got asked if I was prostitute more than once; and I stretched a can of haggis for three days. By that

point, I was over the UK.

Returning to the US, things brightened up considerably. Hosanna, a fellow washer woman I used to act with at the Ren' Fair, decided to take myself and my lifelong friend Patty up to the Dann Sisters' property. The Dann Sisters were in the process of reclaiming the ancestral home of the Western Shoshone, and people were flocking to their aid. We went to help in a cause we barely understood.

The Dann Sisters took Patty and I up to go pine nut picking, which, if you've ever done it, is a sticky mess. Pine nuts release a tar-like substance, and as we were whacking away at the pine cones with our whacky sticks, giggling with each other, the Dann Sisters approached in a hushed, important silence. In their beautiful tongue, they spoke our chosen Native American names, delivered with great pomp and circumstance. We fell into silence, two white girls buzzing with the thought of being given such an honor. When we asked them what it meant, their stern looks broke into a smile, and they laughed arm in arm: "Sisters who act like chickens." To this day, Patty and I still cluck about it.

One memory I will take with me to my last breath was when Patty and I went up to the mountains, to a place recommended to us by the Dann Sisters. On the slope of a hill, with the plains below, was a claw foot bathtub, a rain catchment barrel, and a bucket. Cold water on a hot day.

Stripping down, we filled the tub and laid in it together, her feet by my head, my feet by hers, with the sun dancing on the water. After half an hour we saw clouds in the distance, heading straight for us. As the dust approached we were able to make out manes and hooves—a stampede of painted horses. They stopped about a hundred yards away, rearing, and nuzzling, and rolling in the dirt. They were powerful, and beautiful, and funny.

Even wild horses take time to play.

That trip solidified, for me, how important sisters are in this world, especially after my visit to England, and the false Lady Di.

Adventuring on, I bought a motorcycle, a blue Honda Rebel, and started working with developmentally disabled people with violent ten-

dencies. I loved my job. Every client had their own secret language and it was a challenge to figure them out.

When I had applied, my boss-to-be mentioned how small I was, how it was a violent job, and how I might not be a good fit. I told him I could take care of myself, and I did, receiving only two injuries in four years. The first time, a client and I were clapping hands. Then his eyes changed. They didn't cloud over—they darkened, and I knew I was in trouble. I pulled back just as he head-butted me and launched into a flailing fit. Fortunately, I was in my leather jacket, that I deliberately wore on the job, and I blocked my face until security came. The second time was from a very surly older man with great aim. He had somehow gotten a plastic knife and was threatening to gouge out a counselor's eye, so I stepped in, shielding the counselor, and receiving a fist to the back of the head. I got to see the whole incident from a higher perspective when my body smashed face-first into the wall. I literally saw stars. Not the cool cartoon kind, but a burst of light flaring in front of my eyes. Aside from those two occasions, I had the best record of not getting hurt. I could talk most clients down, and because of that, I did most of the hospital runs. I was put on mobile crisis, and ran the Art Class, because the Art Class had scissors!

I had a particular art student who was amazingly talented. While severely autistic, he could sculpt miniature cities. Despite his sweetness, he was also one of the most aggressive students, being horrifically violent when set off. I remember, he used to grab a book, throw it on the floor, shuffle around the room, pick it up, flip the page, throw it down, and do it all over again. At one point, our center became one of the first in the state to test a new computer program developed in Australia. It had a large keyboard and a unique interface designed for kids with autism. My student was one of the first to be selected to use the machine, and I with him.

Laying his wrist on mine, his shift in weight would move my arm, steadying his shaky fingers to the keys. None of us believed he could write. We asked him a few questions first, to get the process going, but there was no reply. We all expected, and assumed, there wouldn't be. Yet by

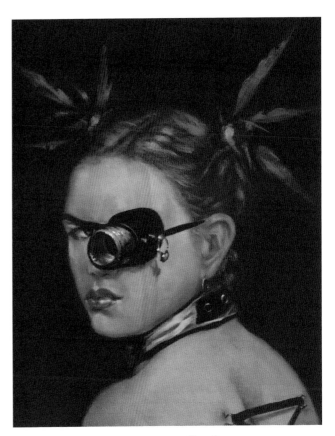

Acceptance Study
Oil and Metal Paint on Belgian Linen
11 x 14 in.

the fifth question: "What is your favorite book?" I started feeling pressure on my wrist.

Slowly, yet with a growing force, he spelled out: *Old Yeller*. At which point we all started crying our eyes out. He was in his mid twenties, yet this was the first time he had ever communicated. It was also the first time that his care providers realized he was not some grown child, but an articulate, intelligent, and beautiful man. Picking up the book, throwing it on the ground, and moving around the room was just his process for turning the page.

After that position, I ran a group home for developmentally disabled adults. At 24, I was still pretty young to be a director, and in hindsight I didn't know half the stuff I should have. Yet there are always people who know less. They hired somebody despite my opposition. I had a really bad feeling about this person. She left bleach bottles open, and scissors out. I became increasingly more angry as she showed little care for any of the clients' well being. At one point, we were performing a two person pick-up, lifting a client

101

with a fused spine from their bed to a wheelchair, and she dropped the client. She just let go, and I, without any back support, caught a 170 lb woman. My arms were stressed, but I was alright. A week later, however, we were in the same room, with the same client, and she dropped her again—and again I caught a 170 lb woman, this time tearing the ligaments in both my arms.

The doctor told me I would lose 80% of my dexterity.

"Can I draw?" I blurted. It was the first thing that ran through my head. "Can I draw?"

I didn't care about brushing my teeth, or eating, or working, but if I couldn't draw? Later on, when I had a chance to prioritize, I realized I could be an artist—that I could actually go to art school. All throughout my youth it hadn't seemed like an option, but only with my arms taken away did I realize how important art was.

So I flew to Kyoto. Why? Tranquility. My amazing friend Mary was teaching English overseas, so I went to Kyoto and learned to meditate. I had to ride a little bike everywhere, steering with my forearms. There was a temple there, far out in the country under a massive tree. I might have been the only gaijin to ever step foot in it. They couldn't speak English, and I didn't know Japanese, so we would pantomime to each other, I with my floppy arms. As we sat, Sensei used to stride up and down and whack us on the back with bamboo, which was annoying. "Damn it, man, I'm trying to meditate!" Then I realized he was relaxing our muscles by having us break pose.

This was just after the 1992 earthquake. Kyoto was in ruins. When I arrived, there was a huge building, the face of it concaved, and you could see the different floors—catty-wonk, uneven—yet people were still living inside, having tea over crumbled parapets. Far from the city, I watched the art of living, orchestrated in square rice fields and woven into handmade kimonos. There's also a really unique art of deception in Japan. I couldn't say I was divorced because that would bring shame on Mary, which might in turn affect her job. Yet being a gaijin, people would tell me their deepest, darkest secrets in broken English unable to tell anyone else for fear of being ostracized. My first week, I heard about a ten year-old

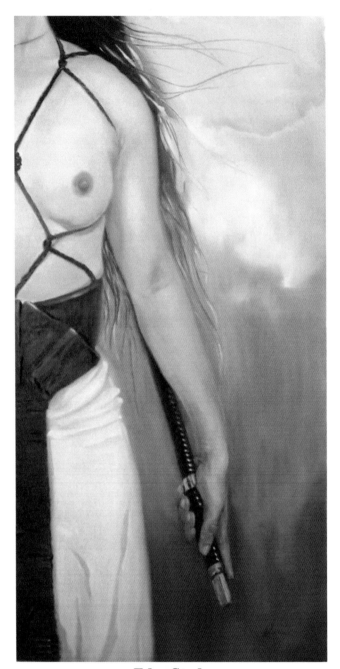

Edge Study
Oil and Silver Leaf on Belgian Linen
12 x 24 in.

boy committing suicide because his bike was stolen and he was too ashamed to tell his parents. That's where I learned repression fosters depression, anger and suicide.

After a while, my arms started working. I was able to draw. As a thank you, I drew small mementos for everyone. I felt very undeserving because I had been given so much, but could only give so little back.

Returning to California, I enrolled at the San Francisco Academy of Art University. With

the goal of financially supporting my parents, I went into computer animation, as that would be the most lucrative. Yet my financial aid was dependent on GPA, requiring straight A's. This was a problem since a straight A student had sued the school after being unable to get a job. As a result, they upped the bar, telling everyone we would have to do three times the amount of
work to get an A.

So I did, completing three assignments for every one. I remember a handful of B's, and possibly a C because I spray-fixed my drawings to prevent yet another teacher from drawing over my work, but I made the grade.

When my father received a letter from President Clinton reinstating his back-pay from the Korean War, I was able to switch majors, focusing on Fine Art with the peace of mind that my parents were well taken care of.

When I started at the Academy, my teacher Bill Mahn told me that I could draw the spirit, but that I hadn't learned how to draw the body. The spirit needs a vehicle to be seen. He said my time would be well spent focusing on anatomy, and understanding how to paint human flesh, to give the spirit something to reside in. I spent the next three to four years focusing on musculature, shape, and skin tonality. I soon fell in love with the sheer diversity of physical form. Our body is our body, be it big, be it small, be it tiny, be it tall, but it's our spirit that makes it graceful or clumsy, and it's the union between the two that creates a sense of character, especially in portrait work. A large person, for example, can feel very small depending on their posture, while a small person can have a huge sense of presence.

One of my favorite memories was of our first live model. Strong and sexy, she scanned the room, found the most innocent country-boy (who happened to be sitting next to me), disrobed, and spread her legs. Her labia were pierced with hoops all the way up. I was fascinated and started drawing immediately. The boy next to me just stared. When break came, he ran to the bathroom and didn't come back. I, on the other hand, didn't leave my seat.

Later, the model and I became fast friends. Her name was Electra. I painted her once as red

riding hood peeking through the veil. The French inscription below loosely translates to: "What will you choose to see once the veil has been lifted from your eyes?"

Veiled Understanding
Oil and Metal Paint on Canvas
20 x 24 in.

It was also around this time that I was blacklisted by Disney®. Their animation department would periodically tour the Academy in search of new talent. That year they had brought the previously unreleased animation, *Pocahontas*. Disney has an amazing animation history, typically acting out scenes with live models, which were then animated. In the case of classics like the *Lion King*, they meticulously studied the motion of animals, yet the first thing I noticed in *Pocahontas* was how odd our lead heroine's proportions were. Her body mimicked a Barbie® doll. At the end of the screening, I asked how they could take a historical representation and make a mockery out if it. This, for a lot of kids, was going to be their introduction to Pocahontas, and in lieu of reading books, they were going to assume that this was how it happened—slapping a happy ending on a

103

tragic tale.

Glaring, the rep pulled out an enormous book of biblical proportions, leaned forward, and asked me for my name. Proudly, I exclaimed who I was, and proudly my name went down in Disney's big book of Who Not to Hire.

Like many art students in California, I eked out a living backstage in the carpentry magic of TV-land: M5 Industries®. I lied to get in. My boss was Jamie Hyneman, known by most as the guy with the thick moustache and beret on Myth Busters, which used to be filmed on location at M5 Industries.

At that time, they were working on a movie promised to be the next *Nightmare Before Christmas*. They lied, too. It turned out to be *Monkey Bone*, a terrible live-action-animation mash-up starring Brendan Fraser. When we went to the preview, my supervisor Todd got me drunk on sake saying: "You're going to need it." I did.

I remember one of the pranks the gang played on a model maker. Perhaps one of the few notable parts of *Monkey Bone* was a town shaped like a hand. It was a beautiful model, which Todd and a few others made a replica of and set on fire, so when the model maker came in they thought the original had gone up in flames. M5 Industries was a world of pranksters—and engineers make the best pranksters. During my first week, Jamie had me working with "The Kicker," which is a compound of cyanide and glue, which has to be eyedropped together. No one told me about the puff of cyanide, which rose up through my nose. As I slowly toppled back, Todd walked by and propped me back with just a casual nod.

If it wasn't for how dangerous it was, that would have been my job. I loved it. It was like playing with toys all day in a huge warehouse filled with knick-knacks, parts, and machines. You would go through and pick what you needed, put it together, make a slush mold of it, and then reproduce from there. I was very good at making things look tarnished and broken-down, which is why I was assigned to make trashcan models for *Monkey Bone's* background props. It was fabulous, fun, and messy.

My boyfriend at the time, Francis, got a call from Lucas Ltd.® the week after he graduat-

ed. He actually had the guts to say: "Let me think about it."

When he accepted, we went to a number of parties at Skywalker Ranch, one of which was on July 4th. It was a giant picnic with a canoe race. I was teamed up with Warwick Davis, whom everyone remembers as Willow from the movie of the same name. We kicked ass. That was also the same day I saw Lucas get egged in the face during the egg-toss. He had a great sense of humor. On another visit to Skywalker Ranch, Francis and I were sitting at the café when out walks Lucas, Spielberg, and Francis Ford Coppola—the cinematic trinity—plotting the next series of blockbusters. Not long after that, we got to see a private screening of *Star Wars: Episode I*. Francis had been working on backgrounds for the production, yet he also got to do the signature for Queen Amidala, being the only one in production to know calligraphy.

The Christmas party that year spared no expense. Even the invitations were exquisite. It was a classic gala with all the glitz and glamour of the San Francisco Coliseum, where I also got to see Lucas get pegged in the balls by a four year old girl zipping around. Wrong place, wrong time. He shook it off with a groan.

Francis and I were very much in love. We drew and wrote worlds together, and when we broke up, I dearly wished for amnesia. So again I left the country to escape heartache. Done with men, I wound up in Ireland with Sylvy, Em, and Isaldi.

Sylvy met me at the airport, sized me up and down, agreed we were both too short to date each other, and took me to a pub. A lavender pub called The George. There I met Em. I was the first girl Em ever kissed, and she knocked my boots off.

The reason I chose Ireland was to attend a one month Irish cultural history class. During that month, the first ever Irish Gay Pride parade marched through Dublin, and I just so happened, in my backpack, to have my chain-mail bikini and my 10 lb shit-kicker boots. The chain-mail a remnant from Ren' Fair, my boots a shadow from the Goth clubs.

I befriended a boy in the crowd who had just come out—that day—and was terrified. Put on

one of the leading floats, his flamboyancy flowered, just my terror arose. Unlike the pride marches I'd followed in San Francisco, there was a real and visible danger in Dublin—especially when the first beer bottle smashed against the float. Em was in the crowd, I couldn't see her anywhere. My guard was up, but the boy kept dancing.

I remember men screaming and yelling and pointing, and an elderly woman, standing in the middle of it all, smiling and blowing kisses through the mob. We didn't have police support. Just a bunch of burly Irish bears at the front pushing through the onlookers so as not to stop the parade. Everyone was protecting everyone, because that parade was damn well going to happen.

In that moment, I had to decide whether or not I was going to stay on that float. And I did. And I was scared shitless, but I took comfort in that old woman, undeterred by all the angry young boys.

Later I met Isaldi, a historian with a PhD, single-handedly translating Irish myths into English, which is perhaps even more astounding since she's blind. On Beltane, Isaldi took me to the Grove, a double circle of twelve ancient trees, each of a different kind: ash, rowen, oak... There's a labyrinth there, and a sacred well from which I drank. I now know what the word "refreshing" means.

A debonair swordsman took me out to the tree circle, Isaldi following five steps behind. He gave me this speech asking: "Would you be horribly disappointed if I didn't kiss you in this enchanted grove?" I said no, and walked away. Isaldi busted up laughing. Apparently, everyone dropped their knickers for this guy, but I was done with men, let alone knights.

I should have kissed Isaldi in that grove.

That evening, I saw sparks flickering in the woods. The traditional ceremony began, after which Isaldi came out fire-spinning poi, which I'd never seen before—her flaming chains arching like butterflies. A twelve year-old girl hopped out with a flaming jump-rope. The men swung at each other with flaming swords, while an old man (one of the former pyrotechnics of Pink Floyd) threw me a fire staff and yelled: "Here, this is for you!"

I looked at it, a little freaked out. What happens if I catch on fire? "Drop on the ground and roll around a bit!" Irish fire safety—very different than the fire safety I later learned in San Francisco. Yet that impulsive magic was my first introduction to my next great love: Fire.

Inspired, I drew a flaming circle in my sketch book and had it tattooed on my back. While many won't believe me, that tattoo actually saved my life.

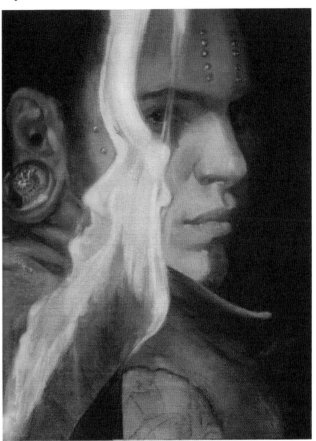

Ardens Study
Oil and Silver Leaf on Belgian Linen
8 x 10 in.

The following year, once I'd returned to the US, I found myself alone feeling unusually maudlin. It was Halloween. Usually, Francis and I would be laughing up a storm at the Lucas Halloween party, as we went every year. This time, however, he had a date, and I decided to have an early night. I rented a movie and headed home. The film I chose was *Destiny*, the classic black-and-white with color paint over the film. I was walking home from the BART station. I was just across the street from my house, looking for my keys, when my tattoo started burning—like someone had put a cigar right in the middle of it. I turned to see what

was up, only to get hit on the jaw with a 2x4 piece of wood.

As I was going down, everything slowed. A voice in my head said: "It'll be easier if you go out...or you can stay awake." I had taken a self-defense class a few years earlier, so I decided to stay awake. The moment I made my decision, gravity sped up, and it felt like—rather than hitting the ground— the ground rose up to hit me. I rolled over, backpack over my head hoping the man would just take it, but instead he grabbed my waist, changing the scenario. His friend opened a car door. Focusing, I did everything I could to break his kneecap with my boot. After he hobbled away with my bag, I ran to my neighbors, knowing you should never go back to your actual house. Later, the cops couldn't believe someone my size could get an attacker to run, though I looked like Quasimodo with a swollen face. Francis came by to comfort me, his date in the car, and later my friends took me out for cherry pie. I didn't eat it. I just stabbed it tiredly with my fork. A church-guy

A Tenet of Sight
Oil on Canvas
9 x 16 in.

106

returned my backpack to me a few weeks later.

My paintbrush, unbeknownst to me, painted a portrait of a strange, ethereal face with red lips and a bright red eye.

My salvation was David Hardy's atelier. He saw something in me from the very start, and granted me a full three year scholarship. A living master, he continued to take classes at the tender age of 70 because he believed you can always learn more. A good artist understands that light and shadow are either cool or warm. If the shadow is cool, the light is warm, or vice versa. Yet David's way of seeing light is truly unique. He doesn't assume that one is merely warm and thus the other is cool. Instead, David showed me how it graduates throughout the image, alternating from warm, to cool, to warm again, progressively dancing between the two, and thinning out, ad infinitum. Perception was always David's great revolution.

The other part of the atelier was Rob Anderson. His training was rigorous. The most challenging I've ever had. You've never drawn a cube until you've drawn a cube in Rob Anderson's class. His sight sizing was so exact, drawings were not allowed to be 1/36th of an inch off. Over the last fifteen years of his life, Rob Anderson exhibited his ever expanding portrait collection *RattleSnake in a Moving Car*, depicting both the portraits and the life stories of people living with HIV/AIDS. Compassion was always Rob's great revolution.

Around that time I met Koyote. He was working as an art model for the atelier. When we locked eyes we instantly knew that we were Burners, denizens of Black Rock City, and the friendship began. As a joke we used to flirt audaciously over the easel. We never did anything together, which made it all the more fun. Friends are sometimes the best people to be sexy with.

In 2004, I was in a car wreck with a municipal train, which popped some of my bones out of place. It took nine months for my savings to run out and six months for my accumulated energy to run out. I say accumulated energy because there's a period when you just keep going. I didn't understand the idea of having an invisible disability.

Disability, as a label, makes you think of

the blind or the legless. Chronic pain is never considered. People are just cranky, or forgetful, or absent-minded, their physical disability dismissed as a personality flaw. Me? I always tried to be optimistic, and because of that I was told my optimism was a form of denial. I wasn't in denial. I'd been hit by a train, but I wasn't going to let it define me, though it took a huge chunk out of my life.

There's an invasive perception that if you're disabled you can't be sexual. When the accident went to trial, I learned that Justice was not only blind, but prude. The lawyers representing, ironically, the rainbow city of San Francisco, used my sexuality against me. The derailed train of thought was that if I liked men *and* women, then I had to have an active sex life, and if I had an active sex life then I must not, therefore, injured. In reality, I didn't have an active sex life. Orgasm equated to muscle spasm and pain, and not in a good way. The whole courtroom drama left me feeling ashamed, dirty, silenced, and restrained. I remember looking down at the body braces holding my wrists in place, and feeling so isolated.

There are a lot of positive affirmations about *loving yourself*, but when you can't think because of physical pain, *loving yourself* seems so far away. It's a lot easier to be patient and forgiving with others, but we can be horribly unkind, cruel, and even violent towards ourselves. I think the first step is to treat yourself kindly and gently, before *loving yourself* even enters into it. Even if you have to treat yourself as a stranger first—would you ever be that mean to a stranger? Would you ever be that condescending? Then, when you can, treat yourself as a friend.

And, above all, don't let the labels stick.

Decidedly, Koyote paid for me to go to Burning Man, bundling me up, body braces and all, and plunking me down, front and center, on the playa at the Lost Penguin Camp. Situated on the Esplanade, the Lost Penguin Camp is a kind of hospitality camp serving wine and chocolate to whoever wanders in out of the desert. They also haul out a bunch of couches, so I got to sit, watching the party unravel like a living Salvador Dali dreamscape.

To help with pain, my friend Schwag-

Whore decided to teach me how to drink. Instructed to guard an extra-large bottle of whiskey, I nursed it all night, through to the pancake breakfast the next morning. Through my buzz, I could still feel the pain, but it took the care away, so I sat, watching the Freak Jug Band play music—a claw-handed woman playing washer-board. Hot-Pants McGee, in her bright short-shorts, was calling people in off the desert, bringing a person to sit in front of me. The first thing I noticed was a mass of perfectly spiraled ringlets, which was amazing, since that kind of hair perfectionism is impossible on the playa: the dust turns everyone's hair into dreadlocks.

Being slightly inebriated—not drunk but happily pre-pickled—I asked if I could pull one. In the most perfect English accent I ever heard, they said: "Of course luv." I melted. When they turned around I saw their bright red lips, which I thought absolutely beautiful, so I asked if I could borrow their lipstick. They looked at me and said: "No, no, luv, these are my natural lips."

That was my first meeting with my amazing muse, Alex. It was the most spontaneous romantic encounter of my life. I remember, as the city deconstructed around us, both of us lying on a mattress, alone in the desert, with the sun rising. Alex is my muse, my love, my pyro paramour, hence my allusion to Borgereau's *Cupidon*, and the viewer's sense of floating. The painting itself crosses two panels to convey Alex's personal restraint and revolution with dichotomy.

In four years, I've watched Alex write nine brilliant books, earn a Master's in counseling, all while working as a security guard on a volcano. I remember, at the end of the night, after Alex had herded the tourists away, we would light our fire toys off the lava, and dance as the asphalt boiled, and the trees burst into flame.

After a Burning Man fire performance at Spike's Vampire Bar, when I popped out my shoulder and hip (which I was totally expecting), Alex scooped me up and walked halfway across the desert, to the med tent. This book you are holding would never have been, if this beautiful person had not fought so hard for my art and my health.

I once attended a mad-hatter's tea-party in

the middle of the desert, at a dining room table covered in dusty teapots. There were cups and teas of every kind. I chose jasmine. The topic was death. Tired of unrelenting, overwhelming pain, suicide seemed reasonable. Alex, in his top-hat, counseled patience and how I would lose, not just my life, but opportunities unimaginable. I gave myself six months to get better, and I did, incrementally, but first I had to create hope.

Too cold to live in San Francisco, I moved to an art commune in Tucson, Arizona, yet the desert, while blazing during the day, is equally cold at night. It was at that point I kept getting signs— some literal billboards, some spiritual serendipity —to move to Hawaii. So I did. Landing on the Big Island, on Pele's doorstep, I found myself in the company of some amazing artists; Devin Mohr, Kue King, and Rod Cameron amongst them. The first thing I discovered was how healing the island was. Within a month my hands began to uncurl and I could actually hold a pencil again. Everything in Hawaii—the energy, the atmosphere, even the land itself—is very new, and very raw. On solstice, I went out with a group of fire spinners called Trans-Fire. I had no idea who they were, but they said that they were going to the lava, so I joined them. There was a guy there in his early 70's, and since he was going I figured I could go, too. My butt got kicked.

They were running ahead like it was the end of the world, and it was so hard to keep up with them, climbing over hills of volcanic glass, but we made it. I was half thinking I was going to die, having no idea how I was going to get back again. We found two pukas—two holes in the ground glowing like a pair of almond eyes. They were the most vivid orange I'd ever seen in my life, peering down five feet to a gushing river of lava. I knew Hawaii was powerful, but then I saw, with my own two eyes, how it was an island of renewal. That was the first time I'd danced with fire since my accident without reservation or fear of pain. I was entranced, elated, and grinning from ear to ear.

Relearning how to paint, I struggled to remember. Eight years of education had vanished into a fog of constant body pain. I consistently have to re-route my memory, employing the same workarounds I used with the developmentally disabled, such as paired associations or covering words when trying to read so as not lose focus. At the same time, constant migraines dull the color senses, so many of my paintings are usually more vivid than life. Re-reading Da Vinci's notes, studying Zorn's color, Borgereau's palette, and Sargent's huge brush strokes, I had to relearn everything, overcoming even basic mistakes (no you can't mix oils and acrylics). As so many of my first paintings would crack and fall apart, I had to learn the art of self-forgiveness, an art I still haven't mastered.

Many people assumed my braces were for bondage, which opened my understanding of BDSM from a medical vantage point. Obviously, there are a lot of people who use bondage sexually, but for some people—and I've met quite a few — it has a medical tie. It relieves pain, making it easier to feel pleasure, so tying that into a sexual situation is a very easy leap. It's much easier to feel sensual and attractive when not bound by pain. As fire dancers, Alex and I began orchestrating circus-style burlesque shows with my friends. Fire fleshing allows you to put fire directly onto skin, which is a very dangerous and sensual art form. This attracted the attention of a lot of kinksters, and I soon found myself teaching classes at leather events, discussing my experience with disability.

Around that time, I received from a gallery in Oregon requesting my work. I told them I could only manage small still-lifes, but the project gave me the impetus to start painting again. My first actual breakthrough was a garlic still-life. Not only was I getting my sense of color back, I was getting a sense of shape and shading. And every time I learned something, it was like I could kind of remember knowing how to do that, like hearing messages from another life.

One of my initial shows was an opening called Spirit Guides, portraying three Kahunas, including my dear friend Kaliko Lehua, who runs a weekly sweatlodge. Kaliko picked me up hitchhiking and we connected on a very deep level. What was so amazing about his sweat lodge is the sheer diversity of people huddled in the boiling dark. Kaliko would lead Hawaiian chants, Kahu would lead Maori chants, and Makhtar would drum Ras-

tafarian prayers. The Spirit Guides show was my thank-you to the island, and the attendance was enormous. An outpouring of people came to the Pahoa Museum.

It was then *Restraint & Revolution* truly began. Looking around at all the fabulous, unique, dynamic and diverse people in my life, I started noticing a common thread. The people who have meant the most in my life were either born outside the box, ejected from the box, or somehow managed to claw their way out. They had all overcome the norm; they had all endured the social restrictions and cut their way out. The most obvious metaphor for this, in my mind, was corsetry. Having always loved the old world charm, it was easy to see how corsetry had changed with time. It was once a garment forced upon women to maintain an impossible ideal hidden under their clothes. Yet after the feminist revolution, we came back to it, transforming this once prude accessory into the epitome of va-va-voom.

I began painting the wonderful people in my life to share their stories, because *Restraint & Revolution* can be seen from two angles. The first, of course, is to feel the painting itself—to grasp the essence, to provoke intrigue. Painting unconventional people in a classical style, for both poetic and ironic purposes, reflects the diversity of elegance by challenging the preconceptions of beauty.

The second aspect of *Restraint & Revolution* is included in this book, since each biography explores a very different side of life and personal identity. Their stories are magic.

I feel we're at a crossroad. Many people are open minded but inexperienced. They're curious, but at the same time they're told not to stare. They want to know if it hurt to get all those tattoos, or why someone would want a subdermal implant, or the history behind scarification, or why that woman has a beard. But at the same time they don't want to appear foolish, or dumb, or insulting by asking their questions out loud. This is where portrait art is unique. Portraiture captures one facet of a person. We're complex. We're changing all the time, and while photography captures a moment, a painted portrait captures an identity. Every one of the amazing people in this series will grow, and

become, and outgrow themselves. Yet I had the honor to take one part of them—one, often misunderstood, revolutionary part of them—and show it to the world, for the sake of clarity and understanding. Because it is only through clarity and understanding that we can change ourselves, the world we live in, and overcome our restraints.

Touch
Oil on Canvas
9 x 16 in.

Photographers

After the initial sitting, Rose Adare typically paints from photographs (it's cruel to make a model sit for 100 hours). As such she would like to thank some of the amazing photographers in her life who made *Restraint & Revolution* possible.

Allyson Seal

An art history teacher, photographer, and social experimenter from San Francisco, Allyson adores dynamic and expressive art. Observing the key interaction between artist and audience, she explores a unique and multifaceted approach to the creative arts.

www.AllysonSeal.com

Anita Nowacka

Anita Nowacka lives and works in Seattle as a family and portrait photographer, where she aspires to create simple photographs under natural light, with deliberate in-camera composition. In addition to commercial photography work, Anita offers personalized coaching and portfolio reviews for anyone interested in improving their photography skills. Anita has been voted "Seattle's Most Awesome Family Photographer" in 2012 and currently works as an instructor for National Geographic Expeditions, a program that teaches students to develop stronger images under the guidance of award winning National Geographic photographers.

www.AnitaNowacka.com

Michael Doucett

Michael Doucett is a self taught photographer living in Seattle Washington, specializing in commercial editorial entertainment and portrait photography. As a self-proclaimed anthropologist he enjoys people of many cultures, which makes portraiture and imagery a perfect fit for his personality. When not doing portraits you can find him traveling, cooking, playing the piano, and writing poetry while the comforting waves crash next to his office window.

Zoe Keough

Adventurer, DJ, and kinky photographer, Zoe lives her dream in Hawaii, snapping shots of volcanoes, beaches, jungles, and all the crazy rockstars who live there. As Adare's in house photographer, Zoe has been with *Restraint & Revolution* since its humble beginning. An inventive genius behind a camera, Zoe can instantly make models feel comfortable, laugh out loud, and show who they really are.

Corsets

Each Corset featured by the models of *Restraint & Revolution* were handmade by either Autumne Adamme of Dark Garden Corsetry in San Francisco, CA, or Iris Viacrusis of Iris Gil Design in Keaau, HI.

Iris Viacrusis

Studying fashion in Paris and theatrical costuming in Los Angeles, Iris' unique and beautiful designs incorporate fabrics from India, Japan, the Philippines, and Hawaii. Combining haute couture with handmade, indigenous materials, his gowns have graced the White House Inaugural Ball and Hawaii's Merrie Monarch. Exhibiting at the Wailoa Center, the Lyman House Museum, UH-Manoa's Hamilton Library, and the Bishop Museum, Iris' precision for detail is as delightfully educational as it is aesthetically pleasing.

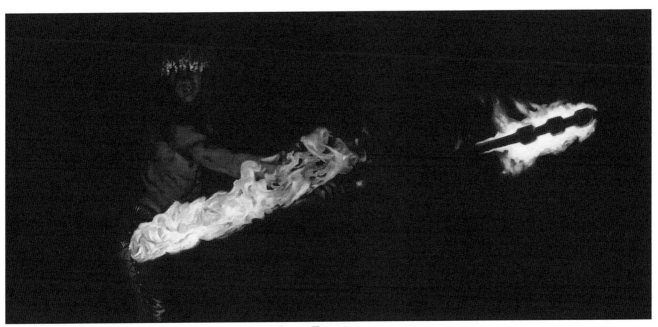

Pyro Paramour
Alex Stitt
Oil on Belgian Linen, 12 x 48 in.

Autumn Adamme

Autumn Adamme founded Dark Garden Unique Corsetry™ in 1989, devoting her career to making people feel beautiful, elegant and dynamic.With a team of stylish designers including Kali Lambson-Bloom's gorgeous wedding gowns, and Kalico Delafey's dapper Dollymop corset line, Dark Garden balances both finesse and imagination.Located in Hayes Valley, San Francisco, Dark Garden has cinched up Marilyn Manson, Dita Von Teese, Christina Aguilera, and Lana Wachowski (to name a few), while simultaneously supporting milliners in their local community.

www.DarkGarden.com

Commedia d'Amore Study
Oil and Metal Paint on Belgian Linen
5 x 7 in.

www.RoseAdare.com